NORTH ALASKA
CHRONICLE:

NOTES FROM THE
END OF TIME

THE SIMON PANEAK

DRAWINGS

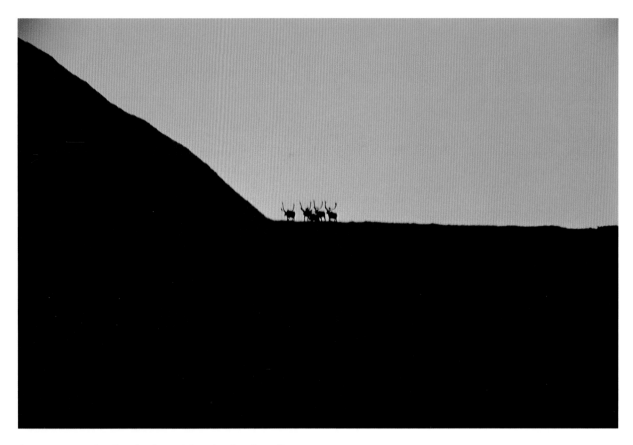

Among numerous American Arctic and Subarctic tribes the caribou,
or wild reindeer, was the staff of life. Photograph by the author, 1957.

NORTH ALASKA CHRONICLE :

NOTES FROM THE END OF TIME

THE SIMON PANEAK DRAWINGS

BY

JOHN MARTIN CAMPBELL

MUSEUM OF NEW MEXICO PRESS

SANTA FE

Project editor: Mary Wachs

Design and production: David Skolkin

Design assistant: Susan Surprise

Maps: Deborah Reade

Manufactured in Hong Kong

Composition: Set in Century Condensed with American Typewriter display.

10 9 8 7 6 5 4 3 2 1

Library of Congress Cataloging-in-Publication Data

Campbell, John Martin.

North Alaska chronicle : notes from the end of time : the Simon Paneak drawings / by John Martin Campbell.

 p. cm.

 Includes bibliographical references.

 ISBN 0-89013-353-0 (hardcover).

 ISBN 0-89013-354-9 (pbk.)

 1. Nunamiut Eskimos—Social life and culture. 2. Nunamiut Eskimos—Social life and culture—Pictorial works. 3. Nunamiut Eskimos—Material culture. 4. Nunamiut Eskimos—Material culture—Pictorial works. 5. Alaska—Pictorial works. I. Title.

E99.E7C235 1998

979.8'004971—dc21 97-44708

 CIP

MUSEUM OF NEW MEXICO PRESS

Post Office Box 2087

Santa Fe, New Mexico 87504

To the memories of
Laurence Irving, William N. Irving, and
Donald George MacVicar, Jr.,
Officers, Gentlemen, Scholars all.

CONTENTS

ACKNOWLEDGMENTS

In addition to Simon Paneak, the three men to whom this book is dedicated, and Michael J. Holdaway and Patrick Wilde, the two Yale undergraduate members of the 1956 expedition, I am indebted to the following of my students and/or assistants for their important help in my studies of Nunamiut history and environment: Noah Ahgook, Herbert L. Alexander, Jr., Charles W. Amsden, Caroline Bierer, Donald M. Campbell, Susan Horsley Campbell, Thomas H. Follingstad, Nicholas J. Gubser, Edwin S. Hall, Jr., Robert Lee Humphrey, Jr., Susan Kaplan, Richard E. Morlan, Mary Elizabeth Nutt, Raymond Paneak, Dennis J. Stanford, and William Taft Stuart.

Mentors and colleagues include Henry B. Collins, Emily Dewry, Richard Foster Flint, J. L. Giddings, Charles E. Holmes, William S. Laughlin, James E. Morrow, Cornelius Osgood, Stephen C. Porter, Leopold J. Pospisil, Loren D. Potter, Irving Rouse, Vilhjalmur Stefansson, and Walter A. Wood. In addition I appreciate the help of Lewis R. Binford.

More recently, Elmer Harp, Jr., Verree Crouder, Megan Johnstone, Ron Peterson, Robert L. Rausch, Marjorie Kilberg Shea, Grant Spearman, and the Reverend William C. Wartes have been exceptionally helpful, as has Peter F. Smith, in whose elegant villa on the Sea of Cortez much of this book was composed.

Financial backing was provided by the American Museum of Natural History, the Arctic Institute of North America, the Explorers Club, the George Washington University, the National Science Foundation, the United States Navy, the University of New Mexico, and Yale University. This writer is most grateful for the help received from these people and institutions, and in addition I extend my hearty thanks to my editor, Mary Wachs, and my book designer, David Skolkin, for their enthusiastic expertise in the production of this book.

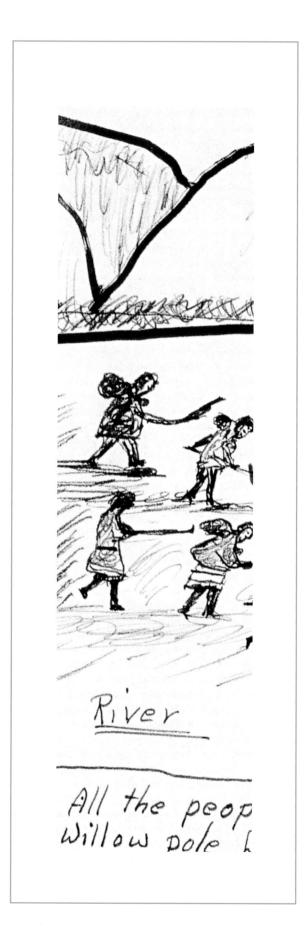

River

All the peop
Willow Dole h

This book is the product of a unique ethnographic approach in which a tribesman is asked to explain his people's history by graphic illustration rather than by verbal testimony. As a member of the 1956 Yale North Alaska Expedition, I met the Nunamiut Eskimo Simon Paneak in an Eskimo camp on the Arctic (Brooks Range) Divide, and from that year until Paneak's death in 1975 (at the age of seventy-five) the two of us were friendly correspondents and fellow travelers.

In the summer of 1967 Simon agreed to my request that he compose a series of drawings having to do with Nunamiut tribal history. I provided a sketchbook and pens, pencils, and crayons, but beyond these materials Paneak was on his own. Except for my requesting a tribal "history," a term that covers a lot of ground, no subject matter was suggested.

His resulting work, accomplished in my absence and completed in the winter of 1968–69, consists of ninety-seven sheets of 12 by 18-inch drawing paper containing unadorned and illustrated texts and annotated drawings. Together they include children's stories, accounts of ancient tribal events, the food quest, clothing and housing, fur trapping, travel, and traditional tools and weapons, some sixty of which are reproduced in the following pages.

Born in the year 1900 in a Nunamiut encampment on the north front of the Brooks Range, Paneak was several years old before seeing a *tunnik*, a white man. As a child and young adult he acquired detailed knowledge of Nunamiut history and technology. The Nunamiut were an interior, tundra-dwelling Eskimo tribe comprised of small, widely scattered bands whose territory lay between those of coastal Eskimos on the north and Athapaskan-speaking Indians and other Eskimos to the south and southwest.

The near extinction of Nunamiut society was initiated in the last half of the nineteenth century by the introduction—albeit inadvertent—of white men's diseases, followed by the enticements of wages as they were avail-

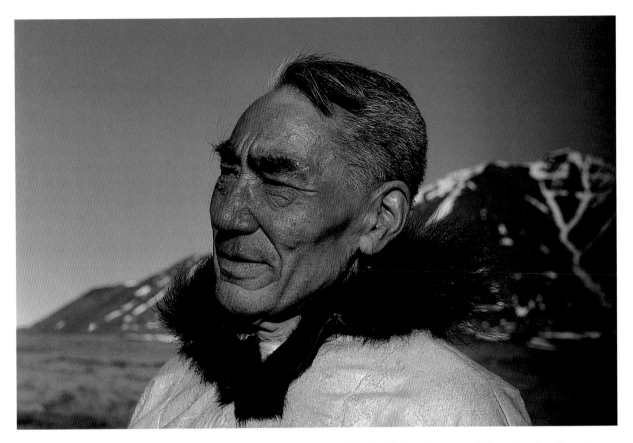

This portrait of the artist was taken in 1967 in our camp north of Chandler Lake where Simon, as mentor and teacher, instructed his three white man companions on Brooks Range cultural and natural history. At the age of sixty-seven, he had survived hardships of degrees and kinds unknown to most readers of this book. And, while suffering still from white man's tuberculosis, until the day he died at the age of seventy-five his exceptional wisdom and skills were celebrated equally by his tribemates and foreigners. Photograph by the author.

able elsewhere in Alaska and northwestern Canada. Consequently, by 1920 all of the Nunamiut had either died of disease or had abandoned their home territory (see Gubser 1965 and Kunz 1991 for this and other characteristics of early-twentieth-century Nunamiut demography). Paneak was among those survivors who emigrated to the Arctic coast in 1920, where he married a coastal Eskimo woman who had been trained by missionaries to be a schoolteacher and from whom he learned to speak, read, and write English.

Then, in the 1930s and in 1940, a few Nunamiut, including Paneak, returned to their native heath. His first wife having died in childbirth, he was accompanied back to the tundra by a second wife, a Nunamiut woman,

and their children. Because of these immigrations, by the time the United States entered the Second World War in 1941 a total of nearly fifty men, women, and children, members of fragmented Nunamiut bands, were living again in the remote interior of the old territory.

The details of why (or how) they returned are not a matter of record, but the most compelling reason seems to have been a longing for home. Reaching their new places of settlement required arduous overland journeys, walking, accompanied by pack dogs, in summer or travel by dogsled in winter, the latter being a mode of transport that involves, too, a great deal of foot travel. Their new encampments were in the regions of the upper Killik River, Chandler Lake, and Anaktuvuk Pass, among the northern ramparts of the Endicott Mountains in the central Brooks Range. As measured by air, from these locales to the nearest jumping-off place south of the mountains (the riverine village of Bettles in Indian territory) is about 110 miles, and to the nearest Arctic coastal shore it is 150 miles, while the actual walking or sledding distances are nearly double these figures.

Once back on home ground, the returning expatriates quite literally took up from where they had left off

This Nunamiut settlement headquarters, probably last occupied in about 1900, seems to have been abandoned because the people ran out of willow fuel. In measuring willow growth rates at this locality we found that saplings twenty-five inches tall were no more than about twenty-five years old. Photograph by William T. Stuart, 1961.

Caroline Bierer stands in a large, semisubterranean house, one of two that we excavated at Tuluak Lake. Furnished with an entrance passage and a central, stone-lined hearth, its artifacts reflect an interior Eskimo occupation of about two thousand years ago. Photograph by the author, 1961.

some years before. Products of the modern world, such as sugar, tea, and rifle ammunition, were gotten by infrequent winter sled trips or from bush pilot traders or other visitors, but with exceptions traditional Nunamiut life, including both its material and nonmaterial qualities, was reestablished. Food economy, as it had been in earlier decades and centuries, was based again on hunting caribou (wild reindeer), with several species of freshwater fishes being collectively the second essential resource.

Through necessity, traditional clothes, houses, sleds, snowshoes, fishing tackle, snares, traps, and other ancient artifacts and their technologies were reintroduced to "everyday" usage. Native medicine made its comeback, as did various religious, social, and political practices. Metal artifacts from the outside world had been in use among the Nunamiut for seventy years or more, and steel knives, saws, and ax blades accompanied the Nunamiut back to their homeland, as did rifles, which in theory at least had become the most indispensable of all modern artifacts.

By about the turn of the century, .25 and .30 caliber repeating Winchesters in Models 1892 and 1894 were owned commonly by Nunamiut men, and by the late 1930s, rifles had replaced the old big-game drives and surrounds (plates 35 and 36) in all of the Alaska Arctic and Subarctic. Having said this, however, it is of interest that in one year during the Second World War when the hunters ran out of ammunition, traditional autumn water drives at Chandler Lake (plate 36) provided enough deer to sustain several families through the following winter.

Paneak was appreciably younger than several of the returning survivors, the oldest of whom were born in the 1870s and 1880s and lived until the mid-1950s or later. We thus assume that these older people had more knowledge of traditional Nunamiut lore than did Paneak. (When we reached Anaktuvuk Pass in 1956, one of them, Morry Moptirak, was still in possession of his ivory flint flaking tool.) But these potentially invaluable informants spoke little or no English and some of them seemed reluctant to associate with outsiders. Additionally, our own other endeavors did not allow for the courtesies and time necessary in working through interpreters.

Paneak, however, spoke and wrote perfectly understandable, if interesting, English. Further, throughout his life he had taken special interest in Nunamiut cultural and natural history. He was expert in native technology and in the manufacture of its artifacts. He had extraordinary knowledge of Brooks Range flora and fauna, so extraordinary, in fact, that our colleague, the physiologist Laurence Irving, once remarked to us that had Paneak belonged to our society he undoubtedly would have been a professional biologist.

Because of these attributes, and his friendly willingness to instruct inquiring outsiders, Simon Paneak came to serve as a principal informant to biologists and anthropologists working in the late 1940s and 1950s, whose publications serve collectively as an essential baseline to an understanding of the traditional Nunamiut and their territory (Gubser 1965; Ingstad 1954; L. Irving 1960; W. N. Irving 1951, 1953; Rausch 1951). Therefore, in the late 1960s it occurred to me that Nunamiut verbal testimony as expressed in the literature could be complemented and enhanced by graphic illustrations of the kind contained in this book.

With typical Eskimo optimism, and with regard, we would think, to privacy, Paneak does not treat the numerous sorrowful events in either his own life or in the history and final cultural disintegration of his tribe, well under way by the time these drawings were rendered. Instead, his work amounts to good, solid ethnography, the sort of document that has its appeal to both anthropologist and layman. Accompanying text, based mainly on my fieldwork of the 1950s and 1960s, is aimed particularly at those readers who have little knowledge of north Alaska and its native tribes, but in any case my remarks are quite ancillary to Simon's drawings. His pictures speak for themselves.

The venture resulting in my first meeting Simon Paneak had its most immediate beginnings when we four members of the above-noted 1956 expedition were landed on the ice of Chandler Lake in the north-central Brooks Range. Our field party consisted of Donald G. MacVicar, Jr., expedition leader and graduate student in geology; Michael J. Holdaway and Patrick Wilde, MacVicar's undergraduate field assistants; and this writer, a graduate student in anthropology whose prospective archaeological and faunal observations were intended to complement

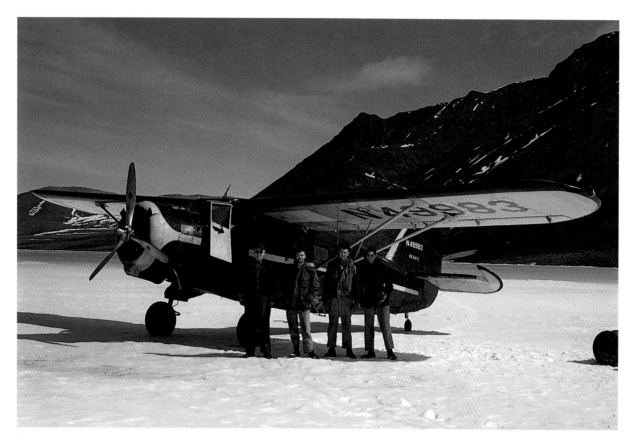

Blown clear of snow by winter winds, the ice of Chandler Lake provided a five-mile-long landing strip for most of each year. In 1956, when this photograph was made, the last of the Chandler Lake winter ice came ashore in mid-July. The Canadian-built *Norseman* is one of the most famous of old-time bush planes. Here, from left to right on the last day of May, are our pilot, Porter Lockard of Wien Alaska Airways; expedition leader Don MacVicar; and Yale undergraduates Pat Wilde and Mike Holdaway. Photograph by the author.

MacVicar's geological and botanical studies. Chandler Lake, five miles long, lies in a narrow, treeless valley just within the northern front of the mountains. The boreal forest's northernmost edge lies thirty air miles southward, and in 1956 the nearest road head lay 170 air miles farther south.

In the last days of May we, along with our food, gear, and gasoline stove fuel, were flown successively to Chandler Lake—whose ice provided a landing field—in a single-engine aircraft on wheels, with the idea that later in the summer we would be resupplied by float plane. Other than for the briefest of visits, no known outsider (nonnative) had camped in the valley of Chandler Lake until the summer of 1955, when MacVicar inaugurated his Brooks Range work from a field base some miles north of our 1956 camp. Indeed, except for occasional Nunamiut Eskimo occupations, the valley had been uninhabited for decades.

Thus, we tented that summer in as nearly an untraveled wilderness as existed anywhere in North America. Fishes, birds, and mammals were abundant and extraordinarily tame. MacVicar and his Yale men mapped mountains upon which no outsider had ever set foot, and we recorded early Nunamiut archaeological localities, including the remains of one encampment whose inhabitants were visited, briefly, by members of the first European–American expedition to explore the Brooks Range (Stoney 1900).

In our late twenties, Donald MacVicar and I had served as officers in separate branches of the U.S. military. Every inch a Marine Corps captain, MacVicar was something of a novelty to Pat and Mike, who were barely out of their teens but who, with his encouragement, became excellent field hands in an environment of midsummer snowstorms and gale-force winds. He was sup-

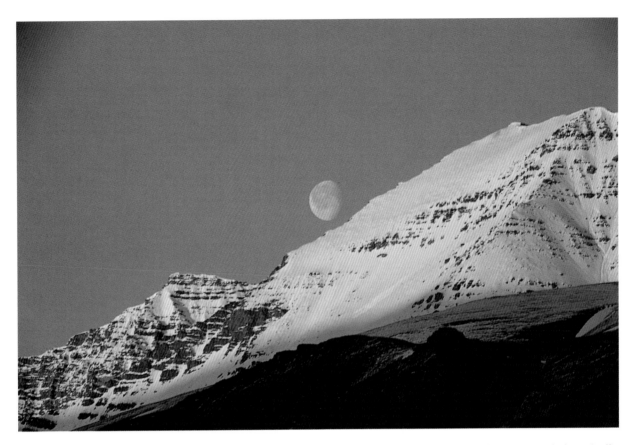

One of the joys of a Nunamiut summer is twenty-four-hour daylight, when in clear weather the Brooks Range peaks and high ridges are sunlit the clock around. This view of the mountain that I was to name subsequently *Mount MacVicar* in honor of the leader of our 1956 Yale North Alaska expedition, was taken at 1:30 A.M. on the second day of June from our camp on the eastern shore of Chandler Lake. Photograph by the author, 1956.

portive equally in my own pursuits, including those that involved several days absence from base camp. On one such overland reconnaissance, at Tuluak Lake in Anaktuvuk Pass, I was introduced to Simon Paneak by Laurence Irving.

Irving was the most distinguished of Arctic physiologists. Additionally, he was Paneak's best white man friend, and by coincidence he had flown to Anaktuvuk Pass, and Tuluak Lake, at the same time we arrived overland. His son, William N. Irving, whom we were to meet in New England the following winter, had been the first professional archaeologist to work in this region, and the encouragement of both of the Irvings was instrumental to my own subsequent north Alaska work over the next three decades.

Then, in mid-July, our 1956 summer ended tragically with the loss by drowning of MacVicar at Chandler Lake. Like the two Irvings, he was a classic example of a keen purposeful scholar, and later it was this writer's privilege to suggest that a mountain near Chandler Lake be named in his honor. An imposing peak, it appears on today's U.S. government maps as Mount MacVicar.

From our first meeting in 1956 until his death in 1975, Simon Paneak remained an abiding friend and associate. My Brooks Range field studies spanned the summers of 1956–59, inclusive, and five additional seasons, most of which involved in one way or another Simon's participation. Following Donald MacVicar's death, I designed my own Brooks Range objectives, whose subjects included archaeology, ethnography, and natural history.

Ironically, the loss of MacVicar accelerated my own work, principally because of subsequent associations with Richard Foster Flint and Walter A. Wood. Flint, MacVicar's major adviser at Yale, and Wood, president of the American Geographical Society (and whose son, Peter, had been MacVicar's Amherst College classmate),

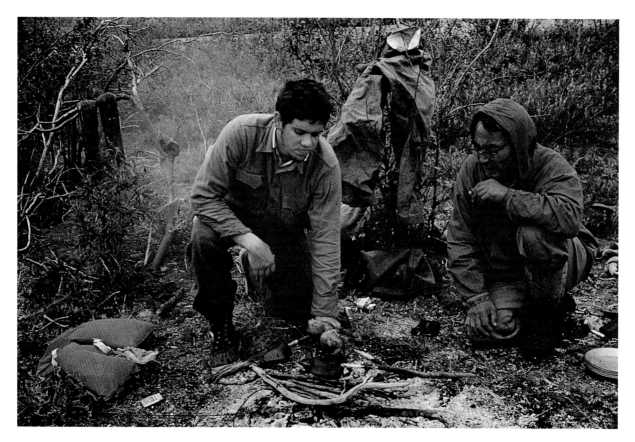

Our 1959 John River reconnaissance, which began on the river's most remote tributary, was distinguished by one adventure after another, including when after running out of nearly everything but coffee, tea, and biscuits we were renewed by Tom Follingstad's prowess with a revolver. Here, as part of that episode, is Nick Gubser being instructed by Simon Paneak on how to roast moose kidneys on a stick. Photograph by Thomas H. Follingstad.

were preeminent in their fields and between them knew practically every outstanding Western scientist whose interests lay in the Arctic. Thus, as an aspiring doctoral student who had been MacVicar's friend, my way to a career in the far north was paved by these two generous men.

Each of my field seasons had as its focus one or more environmental or cultural objectives relating to aboriginal Brooks Range life. As examples, one season was devoted largely to experimental gill netting for purposes of determining numbers and species of central Brooks Range fishes, and in another summer we searched specifically—and unsuccessfully—for traces of the first Americans. Results of these various endeavors

have appeared in several dozen books and professional papers authored both by myself and by several of my advisers, associates, and assistants.

Because of the eclectic nature of our Brooks Range work, help from biologists and earth scientists was essential. In one instance we included geologist field associate Stephen C. Porter in our request for funding to the National Science Foundation. In another year, the plant ecologist Loren D. Potter was our field associate, and such scholars as James E. Morrow (ichthyologist) and Robert L. Rausch (mammalogist and parasitologist), while not our field companions, were advisers from afar.

Simon Paneak served in both capacities: field associate and long-distance adviser. During the winter of 1956–57 we corresponded regarding his knowledge of willow and rock ptarmigan—the Arctic grouse. By mail in subsequent winters Simon provided us with brief accounts of Nunamiut lore, including, for example, the locations of aboriginal Nunamiut flint quarries. Our most lengthy face-to-face association with Paneak occurred in the summer of 1959 when, starting at the summit of Anaktuvuk Pass and accompanied by Tom Follingstad

and Nick Gubser, we floated the length of the John River in two German-built *kayaks* purchased for us by the U.S. Navy.

This was an archaeological and biological reconnaissance, and Follingstad and Gubser, students at the University of New Mexico and Yale, respectively, were exceptionally good field assistants, although their subsequent accomplishments were considerably more exceptional. Gubser, while still a Yale undergraduate, was to write the best book on the Nunamiut that will ever be produced (after which he studied at Oxford as a Rhodes Scholar), and Follingstad, as a major in the U.S. Army Medical Corps, was to quite astonishingly serve out his military service in Africa as personal physician to the Lion of Judah, Haile Selassie.

On that twenty-one-day journey down the river, although I was the so-called expedition leader, Simon Paneak remained our remarkable mentor, and if he were alive today, and if the four of us were to repeat the adventure next summer, we are sure that he would play the same role. At the age of fifty-nine, and suffering from tuberculosis, he was nearly thirty years my senior and more than thirty-five years older than the two college men. On one occasion when, at the head of a particularly bad several miles of the upper river, we began taking turns at lining down the boats, Paneak, tired and wet, most reluctantly permitted the three of us to relegate him to dry ground for the remainder of those miles.

That incident marked the single occasion in which he gave in to our well-meant catering; meanwhile, he instructed us, unobtrusively but continuously, in the nature of the country and how to get along in it. Much of what we learned is contained in the drawings he later created for this book, one outstanding exception being that of his thoughtful explanation of why the Nunamiut were superior to other people. Throughout the trip—which took ten days longer than planned, thus, to our embarrassment, prompting the navy to send a bush plane looking for our wreckage—Paneak's good humor and optimism reflected two of the most critical of survival essentials.

Armed, having fishing tackle, and preserved from serious accidents, the four of us experienced nothing in the way of real hardship. Still, we had our days of being flooded out by monumental summer storms and of going on short rations—the latter of which was resolved when Follingstad killed a moose with his revolver—and through it all we learned from Paneak how such inconveniences ought to be treated.

Given the earthy character of Eskimo metaphor, we shall not repeat Simon's more colorful one-liners. Telling, however, and most appropriate, was his "Better than sunk!" meaning "We are OK" or "All is fine," expressed with a laugh and a throwing back of his shoulders (a Paneak mannerism) each time we got a fire going in a pouring rain, bailed out the boats, caught a few small fish, or whatever else we had done to more or less mitigate acute discomfort. In those three weeks, he became downcast just once, when after having run out of tobacco three days earlier we reached one of my 1958 camps on the lower river where I had cached in a spruce tree a one-pound tin of roll cut. But as Paneak sorrowfully explained when we retrieved the can, I had left it right side up rather than upside down, thus allowing rain and snow to ruin Prince Albert.

These were the ways in which we knew Simon Paneak, both on that journey and on others to come. To our twentieth-century white man's eyes he was an extraordinary man, as indeed he was, but of course by any modern reckoning all of his kind were cut from extraordinary cloth.

The fall of 1961 witnessed what was perhaps the largest Brooks Range caribou migration of the twentieth century. For three days and three nights tens of thousands of wild reindeer moved southward through Anaktuvuk Pass. Lying in ambush, we picked out the largest bulls for the reason that they were larger and far more fat than the cows and calves. Butchered where they fell, their meat was carried to the ice cellars by pack dogs. Photograph by Edwin S. Hall, Jr.

River

All the peop
Willow Dolo L

Alaska, north of sixty-six degrees north latitude, contains three notable biotic zones: boreal forest, arctic tundra, and polar sea, the first two of which encompass 195,000 square miles, a land area three times the size of New England. Topographically, north Alaska is distinguished most noticeably by the Brooks Range, the northernmost reach of the Rocky Mountains, which here trends westward six hundred air miles from Yukon Territory to the Chukchi Sea and from whose summits rivers run north to the Arctic Ocean and south and west to the North Pacific. All north-flowing rivers are confined entirely to the tundra zone while most but not all of those flowing south from the Arctic Divide run through boreal forest.

The boreal, or northern coniferous, forest is an immense woodland that encircles the globe from Newfoundland westward to Scandinavia. From one end to the other it contains remarkably similar, and often identical, plants and animals, a characteristic relating to the so-called Bering Land Bridge, which at intervals over the past one million years has joined Alaska to Siberia. This forest's attributes include long, snowy, and extremely cold winters and short, often hot summers. Over a five-year span in the 1950s, during which we initiated our Brooks Range studies, annual snowfall at Bettles, on the Koyukuk River, averaged eighty-eight inches, streams remained frozen from the last week in September to the second week in May, and lowest winter air temperatures averaged a minus fifty-seven degrees Fahrenheit. At this same locality, highest average summer temperatures were a plus eighty-six degrees F (U.S. Dept. of Commerce 1950–58).

This severe climate is accompanied by the phenomenon known as *permafrost:* deeply frozen ground that never thaws, reaches commonly to within a foot or two of the ground surface and that underlies all of the land area shown in the map on page 21 (as well as much of other arctic and subarctic lands). Plants, accordingly— or at least the roots of most of them—are crowded into a shallow living space called the *climafrost* zone,

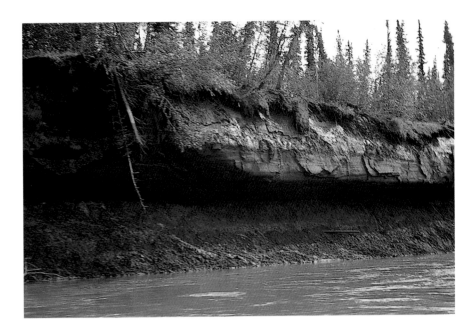

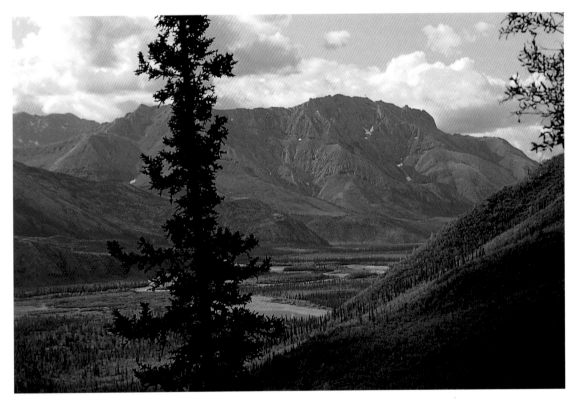

Brooks Range permafrost reaches upward nearly to ground surfaces. All of the shining upper bank shown here is frozen, as was the soil beneath it until a summer flood cut back and melted away its lower part. Within a few hours or days, the undercut frozen bank, spruce trees and all, will crash into the John River, creating a marvelous "boom" that can be heard from miles away.
Photograph by the author, 1969.

Taken from a mountainside looking northward, this picture shows characteristics of the upper John River Valley. Typical mature boreal forest—here consisting of white spruces, black spruces, and cottonwoods—occupies the valley floor. Up slope the trees thin dramatically, and from where we sit on up to the ridge tops, ground surfaces contain only tundra vegetation. Tree line, the southern edge of the true Arctic zone, crosses the valley floor twenty or more miles farther north. Photograph by the author, 1958.

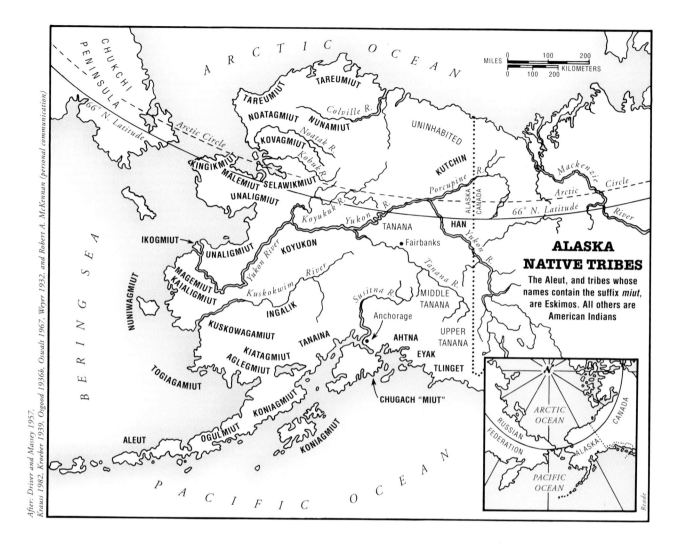

After: Driver and Massey 1957,
Krauss 1982, Kroeber 1939, Osgood 1936b, Oswalt 1967, Weyer 1932, and Robert A. McKennan (personal communication)

ALASKA NATIVE TRIBES

The Aleut, and tribes whose names contain the suffix *miut*, are Eskimos. All others are American Indians

which freezes rock solid in winter and thaws in summer. The underlying permafrost prevents surface water from escaping below ground. Snowmelt and summer rain are either trapped on the surface or are channeled off in streams, with the consequence that during the short summer season the forest floor is extraordinarily wet.

The most overall abundant tree in this boreal forest is the black spruce, the others being white spruce, cottonwood, and paper birch. But because of the latitude and soggy ground, none of them grow very tall, and the black spruces, which of the four are most tolerant of wet ground, are forlorn small trees, their tops bent over like shepherds' crooks, often only twenty or thirty feet tall.

These characteristics, together with the forest's incredible number of streams, lakes, ponds, swamps, and wet meadows, result in an open, sparse woodland rather than anything like most people's idea of what a forest ought to be.

This quality of sparseness is promoted further by the fact that in these regions trees will not grow at elevations higher than about 1,400 feet above sea level. Called the *tree line*, it differs slightly from *timberline*. The tree line, north of which trees cannot grow because of cold climate, is determined by latitude, while mountain-slope timberlines, above which there are no trees (because, again, of cold climate), are determined principally by altitude.

11

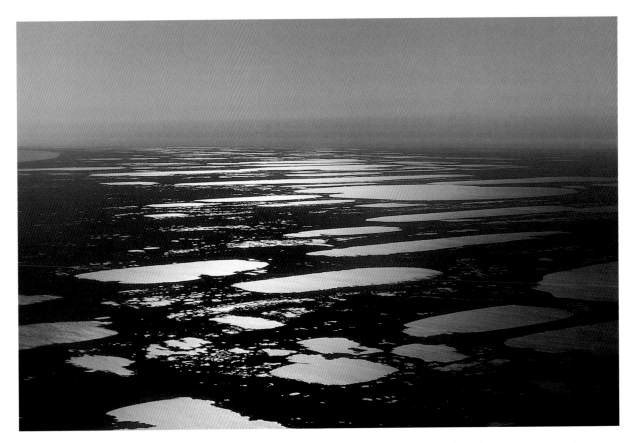

The Arctic Coastal Plain is as flat as a tabletop and filled with thousands of lakes and ponds. Thus in summer this water-filled flatland defies human traverse. To get through it if you do not have an airplane you must travel by river. In winter, however, on foot or by dogsled or snowmobile you can cross it in any direction. Photograph by the author, 1957.

In north Alaska this distinction is muddled. As one travels up the river valleys toward the Arctic Divide, the northernmost forest edge is caused both by increasing latitude and increasing altitude. Not many miles to the south, however, beyond the southern foot of the Brooks Range, timberlines have much to do with the look of the landscape. Ridge tops and plateaus of rolling uplands stand barren of trees, thus enhancing further the openness of the forest zone.

The tree line, nevertheless, separates two remarkably different environments, and although in the longitude of Bettles the Arctic Circle crosses Alaska twenty-five air miles south of the northernmost trees, in environmental terms it is the forest border that marks the true division between subarctic and arctic, a division manifest in several ways. To walk down into the sheltering woods, for example, after weeks on the tundra, is to enter a world where, as it is said, the wind never blows and there is firewood forever.

The downside of this warm refuge from the howling arctic prairies is that in these woods overland travel is nearly as hard as any you will find in North America. We have noted the surface water. Except in canyons and on mountainsides, the country is covered with swamps, ponds, and lakes, and intervening ground surfaces, mountain slopes and all, are covered typically with a thick, spongy mat of mosses and low-growing herbaceous plants. Consequently, the resident Koyukon and Kutchin Indians cleared and maintained trails, and in summer both rafts and bark- and skin-covered canoes were used routinely. We have noted the annual snowfall. Unlike the snows of the tundra, which are commonly scoured away by the wind, woodland snows accumulate. Overland winter travel is therefore practically impossible without sophisticated deep-snow transport; not surprisingly, the resident Indians made the best snowshoes on earth.

The above account of the forest is based largely on our experiences in and near the valley of the John River, and we shall use the headwaters of this same stream as an introduction to the tundra. The tree line occurs near the mouth of Publituk Creek, seventy-five air miles north of Bettles, and it is an abrupt transition. You are "out of green timber" (spruces) and on arctic tundra in a matter of yards. In addition to scattered willows along the stream bottoms, from here northward for several miles there are patches of knee-high, or waist-high, dwarf birches and occasional short, isolated alders.

But this is a tundra landscape nonetheless, and once you have crossed the low summit of Anaktuvuk Pass (the Arctic Divide) and have walked on northward down the Anaktuvuk River Valley to the "mountain line," the abrupt north front of the Brooks Range, you are on tens of thousands of square miles of Alaska arctic tundra, whose total area, large as it is, is dwarfed by Canada's and Eurasia's arctic prairies, which, with those of Alaska, encircle the globe as the boreal forest's adjoining northern neighbor. As noted, from east to west the Brooks Range is six hundred miles long. As western and northern New World mountains go, its peaks are not particularly tall, their tallest summits rising less than eleven thousand feet above sea level. But as well as reaching impressively from Canada to the Chukchi Sea, the Brooks Range, over most of its length, measures about one hundred miles from its southern foot to its northern front. Even south of its tree line, because so much of it is elevated above timberlines, the range itself contains additional thousands of square miles of uplands having the same tundra flora as the country north of the mountains, although it is known here, most properly, as *alpine* rather than *arctic* tundra.

When you walk these high, tundra-covered ridges there is always green timber on the canyon floors below, but from the mountain line northward unbroken arctic prairies reach nearly two hundred miles to the beaches of the Beaufort Sea, first over the Arctic Slope and then across the big, perfectly flat stretch of country known as the Arctic Coastal Plain. From the forest northward, the climate becomes increasingly cold, not as regards record low temperatures (the ocean, even when ice covered, has a warming effect on neighboring lands) but in average

annual temperatures and average seasonal temperatures that, when translated to lengths of growing seasons, determine the presence or absence of plant species (as noted in reference to tree line and timberline).

This regional south-to-north temperature cline is illustrated by comparing data from Bettles with those of Anaktuvuk Pass and Point Barrow. Again in the 1950s, at Bettles, average annual air temperature was 19.7 degrees F; at Anaktuvuk 13.4 degrees F; and at Point Barrow 9.9 degrees F. Translated into lengths of growing seasons, as reckoned by the U.S. Department of Agriculture, the growing season at Bettles was ninety-nine days, at Anaktuvuk thirteen and a half days, and at Point Barrow a remarkably short three days. Further distinguishing north Alaska is its south-to-north cline of diminishing annual precipitation. Including the previously noted average annual snowfall in the vicinity of Bettles— eighty-eight inches—average annual precipitation at that locality was 12.50 inches; at Anaktuvuk 12.32 inches; and at Point Barrow 4.6 inches (U.S. Dept. of Commerce 1953–58).

According to the traditional geographer's yardstick, any large landscape that receives less than ten inches of total annual precipitation is defined as a desert. Therefore, in north Alaska most of the country lying between the Arctic Divide and the Arctic Ocean qualifies, although, as we shall note further on, it is a strange desert of abundant surface water, a condition resulting, as in the case of the boreal forest, from the seal provided by permafrost. Unlike the forest, however, as impoverished and sparse as it is, the country north of the mountain line is a remarkably barren land, more than 99 percent of its ground surfaces being covered with vegetation only a few inches tall.

In summer, because of the permafrost, most of this ground is wet to one degree or another, and on the Arctic Slope especially, as distinguished from the Arctic Coastal Plain, wet ground is dominated by a sedge called arctic cotton grass, which in its awesome abundances grows in short, crowded clumps, the bane of any but the most indefatigable of modern walking enthusiasts. On the slope, this abominable walking is relieved occasionally by low ridges and hills, some of which are relatively dry and support, accordingly, such delightful small plants as

bearberry, crowberry, and gnarled rhododendrons, none of which reach above ankle height.

Of similar stature, there is a ubiquitous dwarf willow, six inches tall, and there is another, much larger willow that is anything but ubiquitous but instead is restricted in scattered stands to particular streamside and sometimes lakeside localities (see Hulten 1968 and Wiggins and Thomas 1962 for detailed accounts of north Alaska flora). As explained further in chapter 2, the occurrences and distributions of these big willows, some of them ten feet tall, were critical to the Nunamiut way of life, and in our first season or two in this country, to find a willow thicket was to momentarily, at least, escape from as empty a wilderness as one could ever imagine.

Still, from Anaktuvuk Pass to the ocean there are not enough willow thickets to come remotely close to spoiling the barren nature of the tundra. Still, barren as it is, it can be a wondrous landscape. With crew member Ed Hall, in the summer of 1961 I rafted down a long reach of the Itkillik River through the greenest of green prairies filled with multitudes of game. Night and day— the arctic summer nights being nearly as bright as the days—there were geese on the river bars, hundreds of grazing caribou in every direction, some of them at our tent door, and big, dark moose looming up at ranges of a mile or two. The rafting was easy; for once the Arctic Slope weather was warm, calm, and clear, and there were noticeably fewer millions of mosquitoes than usual. Twenty miles across country our companions Herb Alexander and Bill Stuart were walking overland in the direction of an unnamed lake that we had picked from a government map and where, on a prearranged day, we were to meet a bush plane. But meanwhile, the four of us had quite a few thousand square miles of Arctic Slope strictly to ourselves.

The adjoining Arctic Coastal Plain, as we have said, is perfectly flat, so flat indeed that from ground level its horizon has been described as being ten miles away and ten feet tall, and it is distinguished further by thousands of lakes and ponds, a characteristic that makes summertime cross-country travel virtually impossible. Ground surfaces, invariably wet in summer, are covered with a smooth mat of grasses, sedges, and other herbaceous plants, but in our experience, and to our delight, they

lack the sedge tussocks of the Arctic Slope. Interestingly, the closer you approach the ocean, the more diminutive become the plants. The northern parts of the coastal plain, for example, contain none of the big willows we have noted.

The Arctic coast itself is one of small tides, low surfs (except during uncommon heroic storms), and narrow mud beaches, and along much of this northernmost Alaska, sea and land merge nearly imperceptively. Commonly, saltwater and adjacent ground surfaces above high-tide mark are separated by banks no more than two or three feet tall. With the plain being so low and flat, when walking up from the south in summer you discern the ocean from the gleam of its offshore pack ice. In winter this land–sea boundary is obliterated totally by ice and snow.

Aboriginally, Alaska north of sixty-two degrees was inhabited by both Eskimos and American Indians, some of whose descendants remain today in or near their traditional territories. The northernmost forest was occupied nearly exclusively by two Athapaskan-speaking Indian tribes, the above-noted Kutchin and Koyukon, whose members lived, respectively, in the wooded drainages mainly of the Porcupine and Koyukuk rivers. One Eskimo tribe, the Kovagmiut (Giddings 1961), was headquartered on the forested Kobuk River, but with this exception all north Alaska Eskimos inhabited either the tundra and its rivers or the Arctic Ocean littoral. They included the Noatagmiut (Noatok River), Selawingmiut (Selawick River), Nunamiut (mainly of the Colville River and its tributaries), and the Tareumiut of the Arctic coast.

Present-day knowledge of these tribes derives first from nineteenth-century evidence collected by white sailors, traders, trappers, and military explorers and second from the work of twentieth-century U.S. Army officers, ethnographers, archaeologists, biologists, and others. We now have, therefore, a useful picture of north Alaska tribal characteristics as they were in late aboriginal times (to the 1850s or thereabouts) and in some instances as they had prevailed in earlier centuries.

Still obscure, however, are the reasons why the Indians were forest people while the Eskimos, nearly without exception, were tundra or coastal dwellers.

North Alaska Indian colonizations seem to have preceded those of the Eskimos by several thousand years, so it might be argued that the late-arriving Eskimos got the less desirable geographical leftovers. At the same time, as described below, the western Arctic coastal Eskimos possessed sea-hunting technologies so effective that they lived in a luxury never attained by the north Alaska Athapaskans. And the picture is clouded further by Indian tundra encampments that testify that the tundra was Indian domain before the Eskimos got there. Thus, there is the intriguing possibility that the late-coming Eskimos drove the Indians into the woods rather than it having been the other way around. In any case, over at

least the past few centuries, with few exceptions the tundra and coasts have belonged to Eskimos while the forest has belonged to Indians.

As we have shown, the boreal forest differs from the arctic tundra in notable respects, but their native human food resources, particularly the most important ones, were, and are, closely congruent. At first glance, it would seem that the forest-dwelling Indians held a subsistence advantage. The forest contains appreciably more plant and animal species (including invertebrates) than does the tundra, and in reference to well-known edible plants such forms as blueberries, cranberries, and rose hips, among others, are common or abundant in the woods but are relatively uncommon or rare on the arctic prairies. Similarly, among vertebrates the ruffed grouse and spruce grouse are restricted to the forest, as are the marten, river otter, red squirrel, beaver, muskrat, and snowshoe hare. And the black bear, although in the habit of wandering on the tundra, is a forest creature primarily (Bee and Hall 1956; Burt and Grossenheider 1964; Rausch 1951, 1953).

On the other hand, the wild reindeer was the single most critical subsistence resource for northern interior

Like the North American wild reindeer, known as caribou, the American moose (*Alces alces*) has its precise genetic counterpart in northern Eurasia, where in English it is called "elk." Known to the Nunamiut as *tutuvuk*, it is typically a forest animal but in north Alaska ranges commonly on the tundra. The amazing "tameness" of mid-century Nunamiut territory animals is reflected in this bull, which had never before seen a human. Legs astraddle and hair up on the back of its neck, it is pondering here on how best to tear down our tent camp. Photograph by the author, 1961.

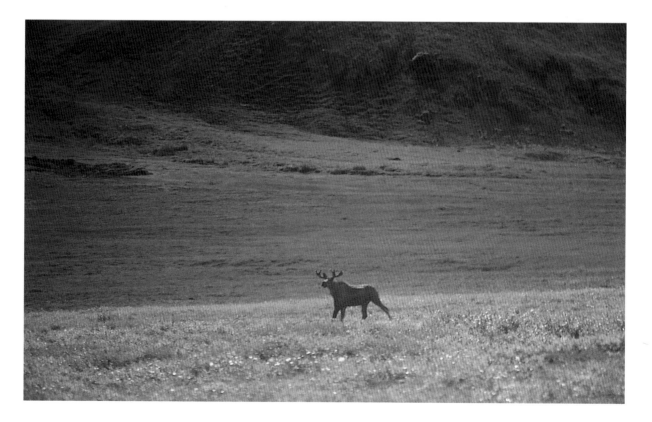

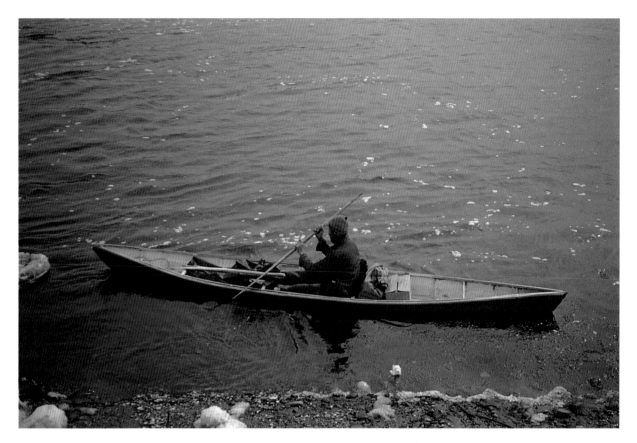

Big Charlie Suckick, who died in the early 1950s, was a Nunamiut man who spent most of his life down in the wooded Indian country. Here, at Bettles, he is starting off to shoot muskrats in a canoe of aboriginal Indian design but covered with canvas rather than bark. This is one of numerous examples of north Alaska Indian–Eskimo cultural exchange. Photograph by Verree Crouder, 1948.

Indians and tundra Eskimos alike, and collectively fishes of the same or similar species composed the second most critical food for both peoples. Further, neither aboriginal population densities nor band (community) sizes seem to have been larger for the Athapaskans than for their prairie-dwelling Eskimo neighbors. In fact, my own boreal forest work shows that in some instances, as for example the Middle Tanana, Indian densities and community size were noticeably smaller than those of the Nunamiut, whose population demography is described in chapter 2.

Given their similar or identical subsistence sources, one appreciates that Kutchin–Koyukon–Nunamiut food-getting technologies were much the same. While most hunting and fishing artifacts had their distinctive Indian or Eskimo stamp, these differences were overwhelmingly stylistic rather than functional. Killing and processing the same sorts of game and fish suggest the same sorts of

methods, techniques, and tools; thus, the Nunamiut hunting and fishing kit (as illustrated in Paneak's drawings) was impressively akin to those of the Indians (Campbell 1972; Nelson, Mautner, and Bane 1982). Many of these similarities unquestionably reflect borrowings. Of numerous probable examples, Osgood (1936a, 57) reports that the large skin boats of the Peel River Kutchin were borrowed in general design from the coastal Eskimos; Nunamiut snowshoes (plate 54) originated with the Indians; and the Nunamiut and Tareumiut "mens' house" (*kasigi*), the Nunamiut hemispherical tent, and the Tareumiut, and possibly Nunamiut, conical tent (see below and plates 14–15, 20) had their Indian correlates.

Among Nunamiut–Indian material culture differences, the most noticeable included the compound, sinew-backed Eskimo bow (plate 37), as compared with the Indian longbow; the bark-covered Indian canoe, as distinct from the Eskimo skin *kayak* (plate 56); and the Koyukon semisubterranean winter house (Clark 1996), which in recent centuries was not used by the Nunamiut (although it is a most ancient, far northern dwelling type and until about the beginning of the twentieth century was the typical Tareumiut winter house [Murdoch 1892;

Spencer 1959]). Small artifact dissimilarities included Eskimo–Indian variations in, as examples, arrows, fishing gear, knives, and skin-dressing tools, and these sorts of distinctions, stylistic as they are, permit, usually, the inquirer to identify prehistoric north Alaska archaeological assemblages as being either Eskimo or Indian.

Importantly, however, all material culture distinctions were inconsequential when compared with social and linguistic differences between the two peoples (Clark 1996; Gubser 1965; McKennan 1965; Osgood 1936a; Spencer 1959; Van Stone 1974). The Koyukon and Kutchin reckoned their kindred unilineally, most particularly matrilineally, as compared with the bilateral Eskimo system, and they were matrilocal, unlike the Eskimos who had no binding rule of residence. The Indians had a complex clan, or sib, system, lacked by the Eskimos, and Indian political organization was notably complex compared with that of the Nunamiut.

The Indians practiced slavery, an institution unknown to their Eskimo neighbors. They were far more religious than were the Nunamiut, having intricate beliefs and practices relating to birth, death, girls' puberty, menstruation, and the spirit world at large. Beliefs in omens, often dire, and observances of taboos were integral parts of Koyukon and Kutchin tribal life, while the Nunamiut, typically, paid them little heed. Then, linguistically, Athapaskan and Eskimo were languages incomprehensibly foreign to one another, and genetically, even, there were marked differences. Thus, after all, north Alaska Athapaskan societies differed profoundly from those of the Eskimos, and the forest-tundra border marked a line of ethnocentric distrust.

North of the Nunamiut and their territory lay the Alaska arctic coast and its native people, the Tareumiut Eskimos. Here, most littoral settlements, including those of both the Tareumiut and their progenitors, were concentrated west of the Colville River delta, and what may be termed *population centers* were, and are, restricted to the north coast between about Point Barrow and Point Hope. Eastward, from the Colville to the Canadian border and beyond, human settlements were sparse and scattered (some maps, including that of Kroeber 1939, show this

region to have been uninhabited), chiefly for lack of game animals, a characteristic that holds true to the present day. On one low-level aerial reconnaissance between the Canadian border and the Colville delta (map 2), we found only a dozen scattered seals on the offshore ice, and on another, a week-long summer examination of the shoreline (in which we were supported by helicopter), game in its entirety consisted of three grizzly bears and a small herd of caribou.

On both these and other similar journeys, signs of human habitation were remarkably scarce. We found a few prehistoric Eskimo winter houses and a few Eskimo and white camps, nearly all of which had been deserted since the 1940s and which reflected the last days of the fur trade as it related here to trapping arctic foxes (see caption accompanying plates 47–48).

But from Point Barrow, south-southwestward, it is a bustling coast. When, in the first half of the nineteenth century, European sailors first explored northernmost Alaska, they found at such places as Point Barrow Tareumiut Eskimo villages containing more than three hundred inhabitants. There were several of these big settlements, the oldest of which, as determined by recent studies, had been occupied more or less continuously for one hundred human generations (Stanford 1976), and they were of sizes and elaborations nearly unheard of among most historically known Eskimos. The luxurious Tareumiut way of life was based on a complex technology developed over thousands of years for the main purpose of killing sea mammals, and unlike the more eastern coast described above, the reach between Point Barrow and Point Hope contained amazing numbers of animals (and does still, as this writer has witnessed). These included at least five seal species and minimally six whales, nearly all of which were common or abundant at certain seasons of the year.

There are no edible plants on this coast; as noted, the annual growing season at Point Barrow lasts for three days. There are the occasional caribou, and a few birds were important in the Tareumiut diet, particularly eider ducks. Additionally, several fishes were eaten, but Tareumiut society was founded on whaling, with seal hunting a second, critical pursuit (Murdoch 1892; Spencer 1959; Stanford 1976; Stefansson 1914).

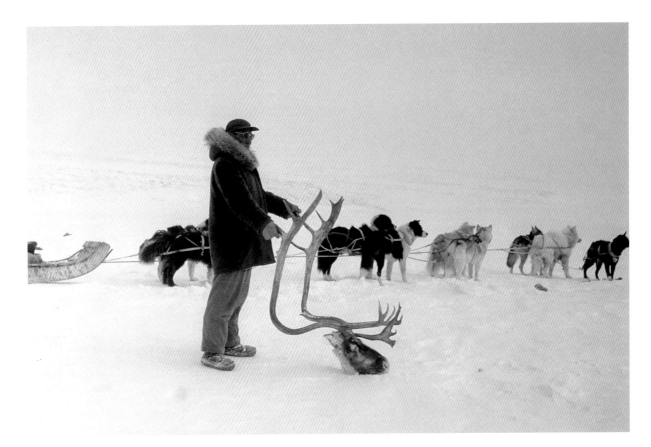

Here in the high country near Anaktuvuk Pass is a Nunamiut
hunter with his dog team, whose members, in the usual Western
Eskimo fashion, are hitched in tandem rather than in the fan. The
hunter poses with the head of a caribou bull shot an hour before.
Photograph by Robert L. Rausch, 1965.

Tareumiut sea mammal hunting resulted in villages
that were indeed towns in much the same sense as were
traditional European–American hamlets. Built in rows,
or clusters, with well-defined paths among them, the per-
manent houses, whose floors lay five feet below ground
surface, were often forty feet long and were accompanied
by aboveground caches and boat racks and subterranean
cellars. Each house contained an elaborate entrance pas-
sage, cooking, living and sleeping areas, and various bins,
benches, and alcoves. Built of whale bones, hand-hewn
driftwood planks, and sod and furnished with carved-
stone lamps, polar bear skins, and other wonderful arti-
facts, it was anything but a primitive makeshift dwelling.

During the extraordinarily short summer, when the
semisubterranean houses became damp and musty, the
people moved into tents of caribou hides either gotten by
the Tareumiut on inland hunts or traded from the
Nunamiut. In addition to these dwellings, each town had
at least one *karigi* (or *kasigi*), a community structure
whose functions varied somewhat from tribe to tribe
(plate 19) and whose role among the Tareumiut was pri-
marily ceremonial. Tareumiut *karigis* were either semi-
subterranean or built on the ground surface and were of
several designs and sizes, the largest measuring at least
thirty-five feet in greatest horizontal dimension. Hung
with magical objects, they were places of religious obser-
vances having mainly to do with whaling and were used
also for primarily religious dances and feasts.

It goes without saying that these political and reli-
gious embellishments were unrelated to the elaborate
beliefs and practices found among the northernmost
Athapaskans. Instead, these and the other complexities
of Tareumiut town life resulted from a most sophisticat-
ed technology that permitted the Tareumiut and their
ancestors, while enduring the most severe climate in all
of north Alaska, to become the wealthiest of its people.

River

All the peop
Willow Dole L

CHAPTER 2
THE NUNAMIUT ESKIMOS

In the early nineteenth century and before, the Nunamiut tribe occupied a region of some sixty-six thousand square miles (Campbell 1968). As was typical of both northern interior Eskimo and Indian societies, the tribe lacked political cohesiveness and was composed of a loose aggregate of bands. It had neither leader nor council nor did it possess the structure necessary to function as a political entity. Rather, its tribal standing derived from the shared characteristics of its member bands. All of the Nunamiut occupied the same tundra environment, based their living on the same natural resources, spoke the same Eskimo dialect, and were alike technologically, socially, religiously, and indeed genetically, attributes which gave them distinctive status among north Alaska Eskimo and Indian tribes.

Just how long the Nunamiut have lived in their traditional territory is a question yet to be answered, nor do we know conclusively where they came from. According to the people themselves they have lived on the tundra since time immemorial. There are the mammoth stories (plates 1–6), and among other accounts the most territorially specific concerns the tall hill, standing to this day near Umiat, upon whose summit Nunamiut forebears took refuge during the time of the Great Flood.

But while these tales of ancient tribal days lack scholarly verification, so does Nunamiut history as opined by archaeologists. Evidence from several hundred localities scattered across the Arctic Slope attests to a long sequence of human occupations, the earliest known of which occurred at least as early as ten thousand years ago (Reanier 1995). This sequence, however, is notably discontinuous. Within this span there are blocks of time, amounting in the aggregate to several thousand years, that to date are not represented by artifacts accompanied by anything like precise dates.

Further, the prehistoric components of the series reflect very little in the way of a developmental sequence or continuum. To the contrary, they are a hodgepodge (Campbell 1962). Those dating earlier than about

2000 or 3000 B.C. (and a few of more recent age) are almost certainly of American Indian origin, but except for this shared affinity the components seem unrelated to one another.

The Eskimos represented show more unity, although again there are notable temporal gaps. The earliest recorded Arctic Slope Eskimos (relatives of the Denbigh Flint Culture, named by Giddings [1964] for its type site on the northwest Alaska coast) are known from dozens of Arctic Slope sites, the oldest of which, presumably, were occupied as early as about five thousand years ago. Then later, between about 2,300 and 1,500 years ago, members of at least two other Eskimo cultures occupied Nunamiut territory, and finally, there are the Nunamiut themselves (Campbell 1962, 1972).

A few regional sites which include Nunamiut artifacts of the last two or three centuries imply, tentatively, that the Nunamiut were derived in situ from Eskimo antecedents who had resided on the tundra for numerous centuries. This is a tenuous possibility, though. The supportive data are thin while nearly all of the abundant presently known Nunamiut archaeological localities are impressively recent. Such items as metal shovel blades, buckets, knives, and gun parts (together with artifacts of native types) are the sorts of things one expects to find in every old encampment containing enough of an inventory to warrant calling it Nunamiut (numerous, regional stone tent rings, for example, lack artifacts of any kind). And further, these Nunamiut localities are typically single-component sites, containing no evidence of other antecedent or contemporary native societies. Therefore, from the cumulative data one concludes that Nunamiut tenure reaches back no more than about 200 or 250 years, a conclusion favored strongly by this writer although lacking confirmation (Campbell 1972, 1976).

The question of where the Nunamiut came from is less complicated, although it too begs for an answer. If the Nunamiut have occupied their territory for many hundreds or several thousands of years, then they reflect typical early Eskimo colonizations from the region of the Bering Strait, colonizations which, beginning some five thousand to six thousand years ago, reached eventually across the top of North America to east Greenland

(Campbell 1964; Giddings 1964). However, if Nunamiut tenure is short, then given that the neighboring forests are almost exclusively Indian domain, they must have come from other interior Eskimo tribes or from those of the Arctic coast, the latter derivation being the most probable, although no one really knows.

Thus do Nunamiut origins remain obscure, but not where and how they have lived for their past eight or ten generations. Beginning in the late 1940s, the testimony of Nunamiut traditionalists had by the middle 1960s produced a small but substantive literature on Nunamiut society as it used to be and, in fact, in some notable ways as it prevailed until the middle of the twentieth century (Gubser 1965; Ingstad 1954; L. Irving 1960; Rausch 1951).

Nearly all of the land encompassed by the Nunamiut tribal boundary lies north of the tree line. The main home settlement of each band was sited farther north, most commonly among the northernmost flanks of the Brooks Range, less often in the rolling country of the Arctic Slope. Occasionally, Nunamiut winter camps were situated within the protective shelter of the northernmost trees. Nunamiut woodland incursions for spruce and birch wood, essential both to Nunamiut domestic life and for trade to the Eskimos of the Arctic coast, while necessary were brief, as the forest, generally speaking, was potentially hostile Indian country.

Much the same can be said for Nunamiut journeys northward to the coast, although the coastal people, being Eskimos themselves, did not pose the same threat. Each summer, members of at least several Nunamiut bands walked and boated down country to a trading rendezvous on a tidewater island in the Colville River delta at a place known as *Niklik* (after white-fronted goose), which annually attracted both inland and north coastal Eskimos whose lives thereby were benefited socially and politically, as well as commercially (plate 19).

The yearly Niklik festivities were short-lived, and Nunamiut ventures farther out to the sea and its beaches were infrequent; indeed, they were less common than forays southward into the forest. Thus, while the Nunamiut were hardly isolated from the world beyond their tribal boundary, home was the tundra and the tree-

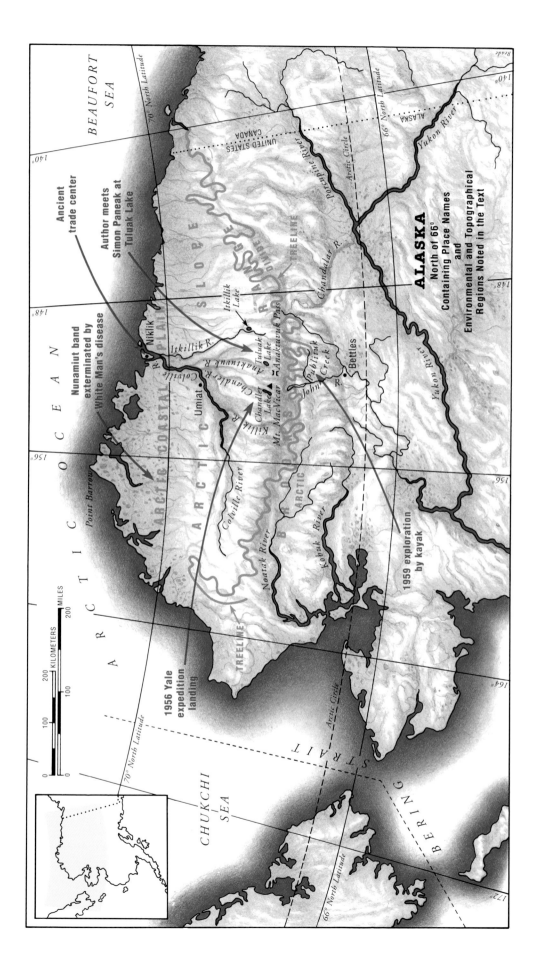

BEAUFORT SEA

70° North Latitude

UNITED STATES
CANADA

ALASKA

ARCTIC SLOPE

Ancient trade center

Author meets Simon Paneak at Tuluak Lake

Nunamiut band exterminated by White Man's disease

Porcupine River

Arctic Circle

Yukon River

ALASKA
North of 66°
Containing Place Names
and
Environmental and Topographical
Regions Noted in the Text

Itkillik Lake

TREELINE

DE LONG MOUNTAINS

Chandalar R.

Niklik

Itkillik R.

A R C T I C O C E A N

Tuluak Lake

Anaktuvuk Pass

Anaktuvuk R.

Chandler R.

Point Barrow

ARCTIC COASTAL PLAIN

Colville R.

Umiat

Publituk Creek

Bettles

Chandler Lake

Mt. MacVicar

Killik R.

John R.

1956 Yale expedition landing

Yukon River

Colville River

A R C T I C

Noatak River

B R O O K S

Kobuk River

ARCTIC

1959 exploration by kayak

TREELINE

KILOMETERS
MILES

CHUKCHI SEA

70° North Latitude

Arctic Circle

S T R A I T

BERING

66° North Latitude

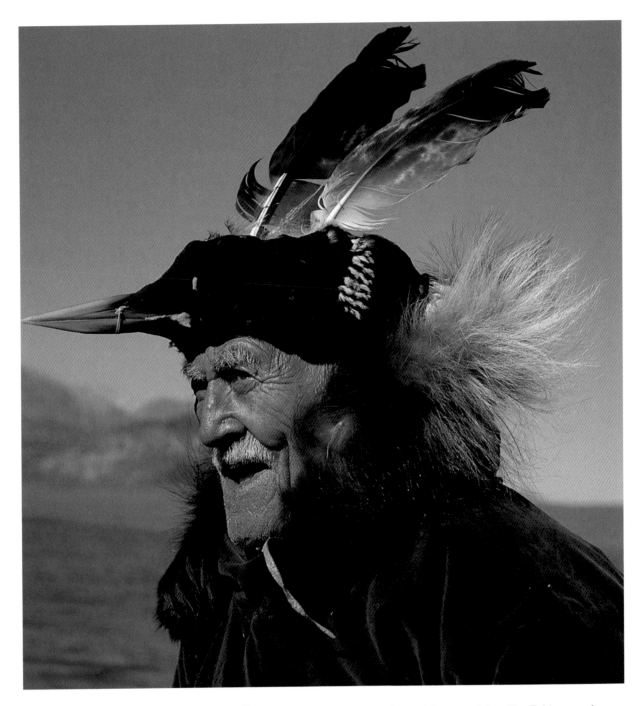

Kakinya, Paneak's best Nunamiut friend, was reputedly an *angatkuk*, a shaman, a reputation enhanced by his mystical appearance and behavior. Supposedly, his knowledge of the cosmos and its workings was of a kind experienced by few other men, and true or not, he did little to discourage this belief. Here, in 1985 in his ninetieth summer, he retains that peculiar luminosity that had fascinated me nearly thirty years before. Photograph by the author.

less north front of the mountains. The Eskimo word *Nunamiut*, in fact, means "land people" (*nuna* = land; *miut* = people) or, more particularly, inland people, thus distinguishing them from other Eskimo tribes, the great majority of whom dwell on seashores.

Before the nineteenth-century introduction of European–American diseases, the total Nunamiut population was probably on the order of 1,400 men, women, and children distributed in perhaps twenty widely scat-

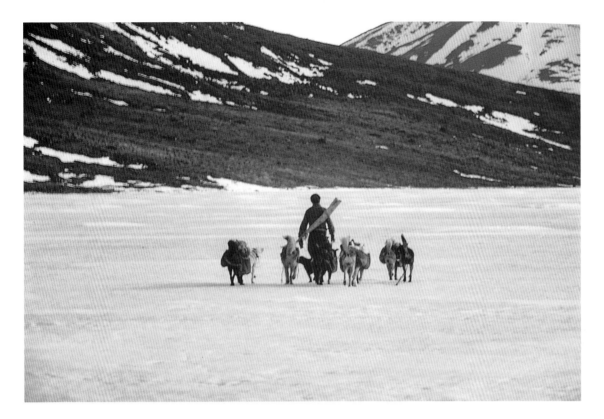

In summer, the sled dogs were put to work as pack animals. This Nunamiut hunter carries his rifle across his back in a caribou-hide scabbard. The rest of his gear and provisions are in the dog packs. Made of caribou hide and in pairs, like saddlebags, the packs were allocated one pair to each reluctant dog, each of which was expected to carry twenty-five or thirty pounds. The hunter and dogs shown here are crossing the ice of Chandler Lake in early June 1956. Photograph by the author.

With the exception, we assume, of mammoth hunting (plates 1–6), Jesse Ahgook, born in 1873, had participated in all of the pursuits illustrated in Paneak's drawings. He was a genteel, outgoing man, "a gentleman of the old school," though our ignorance of the Eskimo language prevented us from inquiring of his invaluable knowledge. In 1956 he carried still his old Yankee whaler's spyglass and his model 1894, .30 caliber Winchester rifle. Photograph by the author.

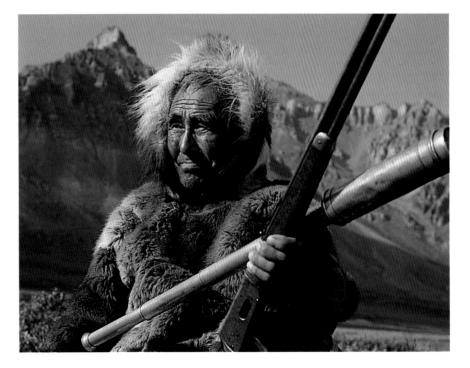

tered bands that together, as we have remarked, constituted the Nunamiut tribe. Each band, because its members survived by hunting and fishing, required an impressively large territory, a bailiwick encompassing commonly three thousand square miles or more, within which the band's principal settlement was sited according to the criteria described below. This home base was occupied much of each year by most members of the community who seasonally, either as individuals or groups, foraged elsewhere in the band's territory (Campbell 1968).

Highly mobile communities, democratic to a fault, Nunamiut bands were composed of eight to twelve families ranging in size from four to seven individuals. By coincidence, Eskimo social structure was nearly identical to that of modern western Europe and America, the exception being that among all Eskimos polygynous marriages (in which a husband has more than one wife) were acceptable and legal. Still, because supporting two or more wives and their children was beyond the means of most Eskimo men, only a small fraction of marriages were polygamous. In Nunamiut society the practice was all but unknown.

The Nunamiut family was *nuclear* in the anthropological sense. It contained two parents, typically two to four children, and commonly an unmarried relative—a widowed parent of the husband or wife, for example. As among modern Americans, there was no *rule of residence*, a social regulation that specifies where the newly married couple ought to live. Depending upon the circumstances, the newlyweds lived with or near the bride's parents or the husband's parents or they lived by themselves.

Further, the Eskimo kinship system, including so-called incest taboos, was the same as that of modern America. Kin relationships were reckoned bilaterally. Because the Nunamiut recognized equally their relatedness to both mother's and father's relatives, no formally established preferences, ceremonial or otherwise, were extended to the kindred of either parent and marriage was prohibited between blood relatives more closely related than second cousins.

Band *exogamy* (marrying out) was not a formal rule, but often within one's own small band one's prospective spouses were either too young or too old or too closely related by blood. Consequently, band intermarriage was common and had the effect of enhancing tribal homogeneity. Meanwhile, marrying a member of another Eskimo tribe (most particularly from the Kovagmiut, Noatagmiut, or Tareumiut), although uncommon, was acceptable. But for the reasons noted previously, Nunamiut–Indian marriages were notably rare.

Band political leadership, as effective as it was, was of the most unstructured and informal kind. Neither hereditary nor elective, it accrued to the man who possessed more than ordinary social and economic skills. He had few, if any, special privileges and exercised influence only by friendly persuasion or, more importantly and frequently, by being followed and imitated by his band mates.

Sometimes religion played a role in this sort of leadership. As mentioned, the Nunamiut (and most Eskimos) lacked the religious elaborations of their Athapaskan neighbors, and Nunamiut religious practitioners did not evoke the awe and fear engendered by their northern Athapaskan counterparts. Still, an outstandingly skillful *angatkuq* (the Nunamiut shaman) wielded certain powers, powers derived most dramatically from his curing of the desperately sick and from his finding game during times of extreme want. His supernatural practices included, in addition, some of a less appreciated kind. A reputed *angatkuq* of my acquaintance, for example, could, according to his band mates, make boots walk around without feet in them, thus creating anxieties in his audiences.

But an outstanding shaman's magical healing of the gravely ill, and his being able to magically save starving people, had the opposite effect. Tulakana was one such man. Probably he was born in the last half of the eighteenth century, but as late as the 1950s he was remembered as truly extraordinary: first, because of skills expressed in the pragmatic ways listed above; and second, because of his ability, during hard times, to kill caribou at great distances using only supernatural weapons.

The Nunamiut annual round was determined primarily by the occurrences of food resources whose distributions required frequent, typically lengthy journeys from place to place in the landscape. In addition to the food quest, visiting, trading, trapping, and the search for

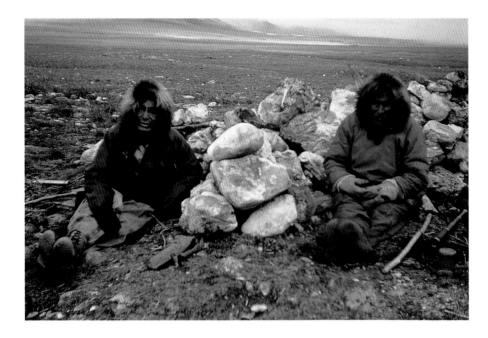

Simon Paneak (left) and his friend Old Hugo wait in a stone blind, built generations ago, for a caribou herd that is still two or three miles out northward but whose approach has been relayed by Nunamiut scouts. Meanwhile, the two men swap stories, smoke Prince Albert roll-your-owns, and every so often look out to see if the caribou are coming. Photograph by Stephen C. Porter, 1960.

Robert Paneak, one of Simon's sons, has rolled this deer onto its back in order to skin it and remove its quarters, for the moment leaving behind its viscera, including heart, liver, and kidneys. Unless butchered immediately, a fresh killed caribou will bloat and spoil. Still in their late summer velvet, the small antlers identify this animal as an adult female. Photograph by Stephen C. Porter, 1960.

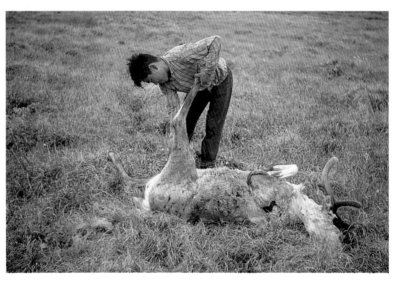

In this picture, Justus Mekiana, one of the excellent young Nunamiut hunters of the mid-twentieth century, is returning from a communal fall hunt with several hundred pounds of butchered caribou. These were rifle hunts, and upon the approach of a migrating herd each man's dogs were left tied securely in camp until the ambush was sprung and the shooting was over. Photograph by Stephen C. Porter, 1961.

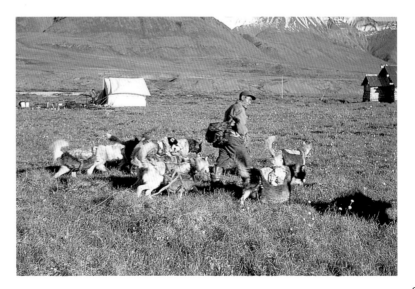

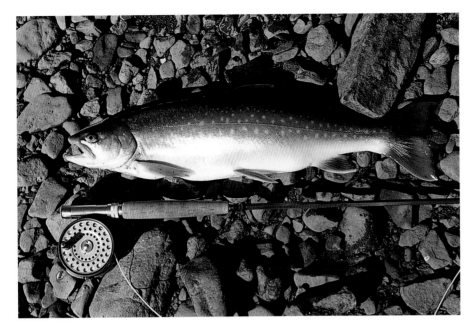

The arctic char (*Salvelinus alpinus*) belongs to the same genus as the lake trout (*S. namaycush*), but unlike that fish, which is confined nearly exclusively to lakes, in Alaska north of the Arctic Divide this char occurs in lakes, streams, and the ocean. In these regions, a big arctic char weighs less than ten pounds. The three pounder shown here has come in from the sea to spawn in the Chandler River watershed, and like its larger cousin, it is excellent food for both man and dog. Photograph by the author, 1961.

raw materials required more or less long-distance travel. Visits to Niklik (plate 19) were longest of all. Closer to home, to name two of many examples, there were journeys to nesting cliffs after gyrfalcon feathers for arrow fletching and to certain bedrock outcrops containing flint quarries. Most such endeavors involved round-trips of anywhere from forty to two hundred walking miles.

Thus, large parts of the Nunamiut country were traversed annually by groups or individuals, and counting all of his travels, the typical Nunamiut hunter and trapper often walked and drove dogsleds more than a thousand miles each year. Travel was anything but random, however. Although hard sledding and hard walking over remarkably rough terrain were such abiding parts of Nunamiut life that they were not given a second thought, when the Nunamiut traveled they went for specific purposes to specific places. And this held true even in times of want, when the search for food was extended beyond the usual hunting and fishing locales.

When, for example, the caribou failed to appear as predicted, at a particular time and place (see below), the hunters, on the basis of their expert knowledge of the animals' habits, went looking for them in other quite specific places. Productive travel, both in good times and bad, demanded intimate knowledge of the terrain, with the result that a rather astonishing array of topographical features had names. The main reason for this welter of names was that of keeping track of the conveniences and inconveniences of the above-noted pursuits. Men or family groups arriving in camp reported foraging and traveling circumstances according to precise geographical positions (see Basso 1996 for more esoteric uses by southern Athapaskans). Therefore, even though their maps were carried only in their heads, the Nunamiut not only knew their territory intimately, they had it mapped in detail as well (plates 32, 59–61).

Again, most travels were concerned with food getting, and while more than 250 edible plant and animal species occur on the Nunamiut native heath (Bee and Hall 1956; Burt and Grossenheider 1964; Hulten 1968; L. Irving 1960; Rausch 1951, 1953; Walters 1955), only a few of them count as subsistence sources. On the tundra, edible, nutritious plants are impressively uncommon. They consist nearly entirely of a few berries and the starchy, large winter root of the sweet vetch. For those who went to the trouble of picking them (in their scarcities), blue-

berries, cloudberries, and the tiny crowberries, the latter of whose fruit are no bigger than the heads of map pins, provided both a direct source of vitamin C and a tangy sweetness to a diet otherwise devoid of sugary fare.

Quite possibly, sweet vetch roots (although the root is not much sweeter than an Irish potato) were more important than berries because with antler tools the big tubers could be dug out of frozen banks, thereby providing a starchy plant food in the dead of winter (plate 41). Then, in spring, there were the likes of sour dock and even the gelatinous, sprouting tips of willows, but all in all, plants hardly mattered. Probably, they accounted for much less than 5 percent of the total annual diet. Instead, to the dismay, we suppose, of modern-day vegetarians, the Nunamiut were meat eaters, and most other Eskimos ate even fewer plants than they. All Eskimos, though, ate all nutritious parts of the animals they killed—blood, livers, kidneys, brains, tongues, and the rest—so that although from time to time the Eskimos suffered hardships, going without vegetables was not one of them.

Both the small populations of each Nunamiut band and their relatively very large territories resulted not from a lack of sociability but rather from the numbers and distributions of food animals. As noted in the previous chapter and in further detail in the plate descriptions of regional animals, the wild reindeer (caribou) was the critically most important mammal, followed by a few others of lesser value. Taken together, though, mammals were the subsistence mainstay by a respectable margin, comprising about 75 percent of the Nunamiut larder.

All but fifteen of the more than 145 birds recorded from Nunamiut territory are migratory and occur in north Alaska only during summer. A very large majority of the total number are small, others are scarce, and still others, such as the two ptarmigan (plate 27), are of relatively very low nutritional value. For these reasons, birds and their eggs were unimportant except as dietary adjuncts or as emergency rations and, like plants, comprised less than 5 percent of the Nunamiut diet.

Fishes, on the other hand, particularly the lake trout and a few others (see below and plates 28–32) were essential, and they often meant the difference between more or less comfortable living and going hungry. Certain fishing places not only had much to do with the location of each Nunamiut band's main settlement but with many of the long overland journeys we have noted. Probably, fishes amounted to 15 to 20 percent of the annual diet. Given these food sources, in ordinary times, by camping in particular locations from season to season the members of each band survived quite well on the animals of their own band territory. Certain marine food sources, especially sea mammal meat, blubber, and oil, were gotten from the Tareumiut (often at the Niklik rendezvous), but these and the seals killed, rarely, by Nunamiut adventurers to the Arctic coast (plate 33) were delicacies and had nothing more than that to do with Nunamiut subsistence economy.

Self-sufficient as the Nunamiut were, however, there were the hard times, or the threat of them, and the topographical position of each band's main or headquarters settlement was chosen with this in mind, as well as for its offering views of the surrounding country and other minor amenities. Caribou, the single most important Nunamiut food source, are migratory and gregarious. Within Nunamiut range, its typically large populations are scattered in summer over the Arctic Slope and Arctic Coastal Plain, from whose barrens they migrate in autumn southward into the forest through the low passes of the Brooks Range. The most efficient, indeed, the only practical way to live by caribou hunting is to intercept their migrating herds in terrain such as mountain passes, where the animals may be killed in large numbers (plates 35–36). Numerous Brooks Range passes lend themselves to ambushing caribou, and the members of each Nunamiut band typically killed these deer in several such valleys or summits. Still, there were the animals' favorite, most commonly used routes, and each band's main settlement was accordingly sited in or close by one of these very best passes where the deer were killed both during their southward, fall migrations and upon their return in spring.

In addition, each main camp was situated near or on the shores of a lake big enough and deep enough to hold lake trout, as well as a few other principal food fishes. As described in the caption accompanying plate 28, lake

trout were exceptionally valuable because of their size and fatness, but among the many Arctic Divide and Arctic Slope lakes, trout occur in relatively few of them. Thus, when combined with a caribou pass, a trout lake from which fish could be caught in all seasons was a second major criterion in locating a main camp.

A final essential was the availability of firewood. With few exceptions, traditional Eskimo fuel was seal or whale oil, but these commodities were so dear to the Nunamiut that when they got them in trade from the coast they were more often eaten than burned. In chapter 1 we have described the willows of the Arctic Slope, and except when the Nunamiut were encamped on the forest border, they had only willows for fuel. Theoretically, the north Alaska tundra contained three other fuel sources: oil (petroleum), which, interestingly, actually puddled (very rarely) on ground surfaces; coal or coal shale; and peat. But mainly for the reason of their scarcities, they were seldom, if ever, used.

Willows, too, can be scarce. Our own experiences include hours of tundra travel (both with and without expert Nunamiut companions) in which boiling coffee or tea awaited the discovery of a few willow sticks. An overnight camp calls for quite a few sticks, and a camp of several days requires a lot of them, so one may imagine the numbers of willows necessary to supply a principal Nunamiut settlement.

As noted, except for the tiny dwarf species, willows on the north Alaska tundra are restricted mainly to well-drained river or creek floodplains, where they are common. Uncommon, however, are truly large thickets of willows, especially occurring in close association with a trout lake and a major caribou pass. A headquarters settlement, inhabited year after year, needed ten or twenty acres of these exceedingly small trees, sometimes growing discontinuously along a neighboring stream or streams but always within a walking mile or less of the encampment.

While their most essential value was as fuel, willows were used additionally for building caches tall enough to keep meat and gear out of the reach of marauding sled dogs, as well as, commonly, for building moss houses (plates 17, 18). Not only, therefore, were these thickets

necessarily big, they had to contain at least some of the relatively tall, robust willows. As I have witnessed, "going after willows" was both in summer and winter a daily routine. Contrary, incidentally, to Paneak's instructions on how to cook a mammoth (plate 5), unless you have a roaring fire to begin with, green, arctic willows will not burn, and "going after willows" then meant walking, or driving a sled, out to the big thicket where a year earlier you had cut your firewood and left it in piles to dry.

Main band settlements contained one or both of two major house types. Casually or in emergencies, the Nunamiut built makeshift overnight shelters (plates 22, 23), but their two principal dwellings were the *itchalik*, the caribou-hide tent, and the *ivrulik*, the moss house (plates 14–18). The hide tent was used both summer and winter and, because of its remarkable portability, was by far the most universal of the two, while the *ivrulik* was nonportable and rather exclusively a cold-weather house.

In addition to these dwellings, a main settlement contained commonly a *karigi*, the so-called men's house, often similar to the hide tent but appreciably larger. The men's house was indeed a structure in which men swapped hunting stories, made bows and arrows and other men's artifacts, and were served occasional meals by their wives. More accurate, however, is Paneak's designation "community hall" (plate 19), because in addition to being a male hangout the *karigi* was a place of oratory, dancing, and other convivial activities attended by both sexes and all ages.

No data are available relative to how long it took to deplete the resources of a main settlement trout lake, but arctic growth rates of some plants and animals are notoriously slow. A thirty-pound Arctic Slope lake trout is often thirty years old, and a seventeen-year-old grayling may weigh no more than a pound and a half. So in theory, and depending upon its size, a main settlement trout lake was fished out eventually.

At the same time, occasional, pronounced scarcities of caribou (Campbell 1978; Skoog 1968) did not result from human predation. Given the usual incredibly large numbers of north Alaska caribou and the exceptionally small human populations, all Nunamiut (and Indian) hunting put together hardly made a dent in the deer

Every Nunamiut household had its aboveground cache, an *ikkiak*, whose most important function was to keep food and gear out of reach of the always ravenous dogs. Here, David Mekiana stands beside an *ikkiak* containing fresh caribou meat hung in the sun to cure. Photograph by Stephen C. Porter, 1960.

herds. Willows, however, or the lack of them, were indeed determinant in the longevity of a Nunamiut headquarters settlement. Sooner or later the camp ran out of willows, a circumstance that necessitated moving bag and baggage to another place whose resources met the required criteria. And once the willows were exhausted, it took several human generations for them to grow back. For example, in an abandoned headquarters locality at Itkillik Lake we found that twenty-five-year-old willows were only twenty-five or thirty inches tall. Thus, for a century or more the trout and the willows were left to replenish themselves, an instance of effective, if unstudied, Nunamiut conservation.

Although each main settlement was occupied variously during much of each year, all or most of its members were in residence during April and May and from August through October, those months embracing the spring and fall caribou migrations. Impounding or driving caribou required communitywide participation and the

closest kind of concerted effort. These hunts were far less structured, and had far fewer participants, than the large-scale buffalo hunts of the Great Plains, but they demanded precision; in autumn especially, with winter coming on, failure could mean extreme hardship. One or more of a band's best hunters commanded each surround or drive while, from long experience and according to age and gender, the other band members played their respective roles.

Then, from November to January or November to March, small groups of two to four families moved to sheltered coves or canyons, sometimes just within the forest border and often many miles from the main camp, where there was dead wood for fuel and adequate game or fish. Depending on the success of the fall hunt, butchered caribou were both brought by dogsled to these smaller encampments and left cached and frozen at the main settlement. Other camps and journeys described in Paneak's drawings were derived from the main settlement or from these winter camps and thus occupied the remainder of the Nunamiut annual round (Campbell 1968).

Under normal, or ordinary, conditions the Nunamiut lived rather comfortably; their houses, clothing, and

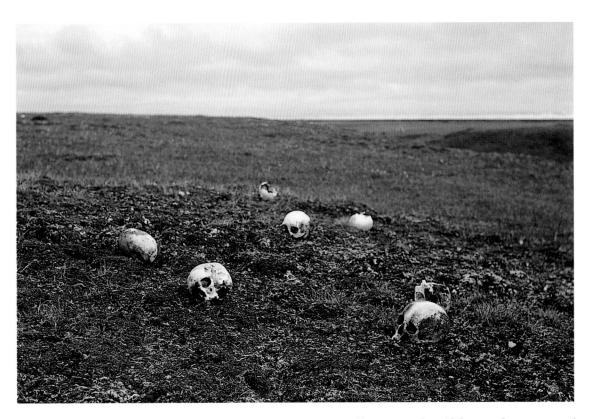

Among traditional Eskimos, the specter of starvation lurked just over the mind's horizon. Indeed, as late as 1958, starvation killed most of the men, women, and children in one Canadian Eskimo band. On balance though, the introduction of European diseases beginning about the middle of the nineteenth century caused far greater destruction among the Arctic tribes. Lying here on the Alaska tundra is a small fraction only of those Eskimos killed in one village ravaged by "the flu." Photograph by the author, 1957.

other artifacts were extraordinarily effective; they were the acknowledged, rightful possessors of their tribal territory; and most of the time they had enough (or more than enough) food. But food scarcity was a chronic threat, and in practically every year there were periods of a few days or more in which some or most members of each band wished they had more to eat. There were several causes and degrees of Nunamiut subsistence hardships, the most common resulting from those seasons when for one or another reason the caribou hunting was poor or when the people ran out of caribou meat between migrations (Campbell 1970). Such short-lived hard times were common and expected, but they were alleviated by falling back on other food animals (see, as examples, plates 25–27, 34). Very rarely did they result in starvation.

Not so were the widely spaced occurrences in which simultaneous crashes of animal populations resulted in a nearly wholesale collapse of northern interior Eskimo and Indian subsistence bases. During such terrible episodes, which were repeated, we think, every four to six human generations, death from starvation decimated Eskimos and northern Indians alike. While pronounced population "lows" of food or game species are common in more temperate zones, as they sometimes occur simultaneously, their effects among aboriginal tribes were far more severe in the long, cold winters of the North.

Quite probably, those forlornly fascinating verses of "Famine," in Longfellow's *The Song of Hiawatha* (1967, 246–50), tell of such an awful winter in the region of the Great Lakes. And so does, probably (again in fictional, but compelling realism), Kenneth Roberts's account in his *Northwest Passage* (1947, 217) of the two starving Rogers' Rangers who at the last possible moment saved themselves from certain death by shooting a lone grouse in the bleak and barren winter woods of New England.

Farther north, records of uncommon but recurring deaths from starvation are anything but fictional. One such episode was illuminated by my Nunamiut acquaintance Elijah Kakinya, who, as recounted by his English-

speaking band mates, recalled philosophically the time when, early in this century, upon reaching his uncle's Arctic Slope camp he found the whole family dead of starvation after, of course, having killed and eaten their dogs. And such occurrences were not restricted to earlier times. In the summer of 1958, our colleagues Elmer Harp and Robert A. McKennan observed an Eskimo band's encampment on the Back River, western Arctic Canada, which contained the bodies of most of its members who had perished from hunger the preceding winter. So in the long run the far northern tribes survived precariously. Little wonder, therefore, that in our overland travels with the Nunamiut we were advised quite continuously on what the tundra offered in the way of food. Such remarks as "Good to eat," "Not good to eat," and "Spoil your belly" were among the more notable of their instructions in Nunamiut lore.

Then, finally, after having survived the aboriginal hazards of the Arctic food quest, Nunamiut society was ruined by nineteenth-century introductions of white man's diseases. As noted, the early-twentieth-century abandonment of the Nunamiut homeland resulted in part from civilization's economic enticements, but disease was the overwhelming factor in the destruction of the Nunamiut tribe, the most grievous recorded example being that of Brower's (1942, 218, 228, 229) eyewitness account of the deaths of some two hundred inland Eskimos who, in about 1899, contracted a disease at Point Barrow and over the span of a few days died on their way back to the interior.

That in the late 1930s, aided only by their own mental resources, a few Nunamiut survivors walked home to the Brooks Range to take up where they left off testifies to a remarkable resilience and optimism documented most rarely in accounts of modern America's underprivileged.

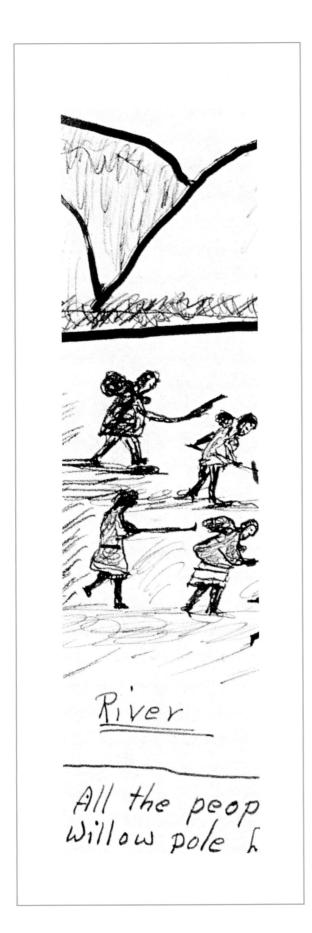

River

All the peop
Willow pole L

Between 1956, the year we met, and 1968, when Simon Paneak began his drawings, traditional Nunamiut life was destroyed by the changes described in what follows. Thus, Paneak's drawings depict from memory a way of life that in a very short time had been lost irretrievably.

The outside world became involved with the reestablished Nunamiut in the late 1940s. These contacts included a few Nunamiut overland expeditions to the Indian–white settlement of Bettles, on the Koyukuk River, but such excursions were rare when compared with visits by outsiders who came to see the Eskimos on their home ground. With the exception of one federal government expedition by tracked vehicle from the Arctic coast, becoming acquainted with the "Artics," as the Nunamiut were known in the regional white traders' lexicon, required travel by bush plane.

Those single-engine aircraft—on wheels for lake landings in winter and on floats during summer—were piloted by white traders or other interested fliers, including James E. Crouder, the trader at Bettles; James L. Anderson, a Wien Alaska Airways bush pilot; and the famous Sigurd Wien himself, of Alaska flying history. These men were followed shortly by hunters and other occasional visitors, many of whom piloted their own small planes.

Typically, the few outsiders arrived with such desirables as flour, tea, knives, ammunition, and bolts of cloth, commonly as gifts or as items of trade or for sale, and often, as a matter of courtesy, they carried out grocery or dry-goods orders to the Northern Commercial Company or to other Fairbanks mercantile houses. The nature of these haphazard Eskimo–white contacts, however, changed decisively in the years 1949 to 1952, pivotal years, as it turned out, in the evolution of the Brooks Range Nunamiut community. Because of the relative ease in which Anaktuvuk Pass could be reached by air, those Nunamiut who had established headquarters in the valleys of the upper Killik River and Chandler Lake moved to Anaktuvuk in August 1949, thus joining their fellow tribesmen who had settled in the latter locality

Alaska became the forty-ninth state on the Fourth of July 1959, and in anticipation of that event we packed in our field equipment that spring a new forty-nine-star flag, not to be unfolded until the first day of statehood. Here, on the morning of the Fourth in the Nunamiut camp at the summit of Anaktuvuk Pass, are from left to right Nick Gubser, myself, and Tom Follingstad. Photograph by Edwin S. Hall, Jr.

and thereby creating a consolidated encampment of sixty-five individuals.

In 1950, a white trader, Arthur J. O'Connell, took up permanent residence in the Nunamiut camp, and a U.S. post office—served once a week, weather permitting—was established there in 1951. Further, beginning in the early 1950s, a few Nunamiut children were flown out each winter to Mount Edgecomb, the Presbyterian native school in Sitka, Alaska. In the 1950s, trapping wolverines and wolves for their furs provided the main Nunamiut income, augmented by a few handicrafts, stipends earned from visiting scientist–inquirers, and, importantly, by a $50 bounty per wolf paid by the federal government (Alaska was a U.S. territory, not a state, until 1959). Killing wolf pups, as well as adults, in early summer was

therefore a major pursuit, although pup skins and summer furs had no monetary value. Bounty and all, though, the average annual family income was pitifully low. This writer's estimate for 1957 pegged it at less than $300.

By the summer of 1956, when I first reached Anaktuvuk Pass, the total resident Nunamiut population was on the order of eighty individuals. Nevertheless, mortality was high, resulting from—in addition to infant and "old age" deaths—such scourges as influenza. Five of the 1956 summer population died during the following winter.

During this time, the medical–dental–veterinary staff at the Arctic Aeromedical Laboratory at Ladd Air Force Base in Fairbanks (now Fort Wainwright, U.S. Army) was becoming interested in the isolated Nunamiut, both for humanitarian and purely scientific reasons. Nunamiut male volunteers were flown to the lab for strength and endurance studies while staff members visited Anaktuvuk to examine and treat both the Nunamiut and their dogs (the sled and pack dogs outnumbered people by a ratio of two to one). Additionally, traffic in both scholarly and romantically curious outsiders increased impressively, numerous of the latter

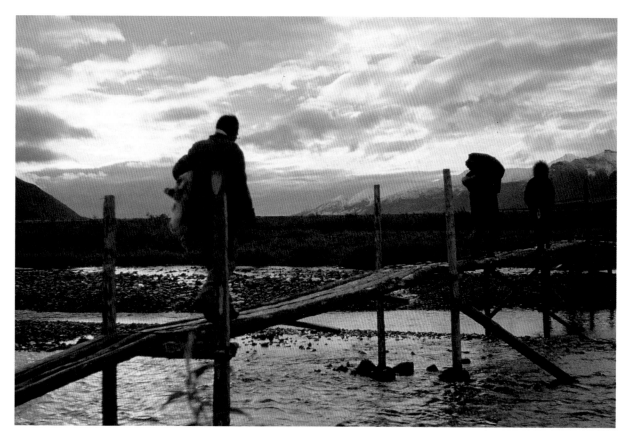

Until 1960, the only Anaktuvuk Pass landing field was a small lake lying a quarter of a mile across Kayuk, or Contact Creek, from the Nunamiut camp. Dry in winter but a bounding cataract in spring and early summer, fording Kayuk was a cold, wet proposition. Unschooled Nunamiut engineers resolved the inconvenience with this elegant spruce-pole bridge. Photograph by Thomas H. Follingstad, 1959.

seeking out Anaktuvuk Pass because of the romantic accounts offered in Helge Ingstad's popular book, *Nunamiut: Among Alaska's Inland Eskimos* (1954), first published in Oslo in 1951 and translated into several languages. The international mix of tourists was accepted with the usual Eskimo equanimity, although some of the outsiders' behaviors caused certain bemusement. (One compassionate, dog-loving lady, for example, following her glimpse of Nunamiut life, chartered in half a ton of dog food.)

Homer Mekiana, a literate Tareumiut man married to a Nunamiut woman, served as postmaster and lay preacher, both post office and church being domiciled in his sod winter house. Several months' worth of "Sunday Pics" (pictures), accompanied by scriptural readings and

mimeographed hymnals, were flown in from time to time by the Reverend William C. Wartes, the Presbyterian missionary at Point Barrow. Wartes, piloting his own small Cessna, the *Arctic Messenger*, reached Anaktuvuk first in 1952, and his purposes there—as well as at other far-flung north Alaska Eskimo villages—included officiating at marriages and burials, albeit commonly, and, from necessity, some weeks later than their actual occurrences. In 1958, while the post office remained in Mekiana's sod house, the Nunamiut built a church of spruce logs cut in the woods of the John River and hauled by dogsled thirty or more overland miles to the Anaktuvuk settlement. The first schoolteacher taught for several months in the village in the late 1950s, school being held in the church until a schoolhouse was built in 1960.

Then, the 1960s and 1970s witnessed a wholesale invasion by the modern world. Arriving overland, bulldozers from both north and south of the Brooks Range reached the settlement in various years during the decade of the 1960s. The first of them, arriving from Umiat in 1960, built an Anaktuvuk landing strip large enough to accommodate multiengine aircraft, and air

freight cargos soon included snowmobiles and wheeled all-terrain vehicles whose advent was to result in the extinction, at the hands of the tribesmen, of Nunamiut sled and pack dogs. In the 1970s, the Alaska Native Claims Settlement Act, along with the construction of the Alyeska (Trans-Alaska) oil pipeline, provided Alaska natives with land, formally organized village and regional corporations, large cash awards (to both tribes and smaller communities), and to some of them, including the Nunamiut, lucrative jobs on the oil pipeline.

These encroachments and their opportunities caused transformations in Nunamiut life of astonishing proportions. On my most recent visit, in 1985 (numerous progressive changes have since occurred), the Nunamiut encampment had become a modern town of platted streets, split-level homes, home telephones and television sets, a hotel, and a restaurant. The school complex, whose main housing was built in the years 1978 to 1980, contained, in addition to a modern library whose holdings included early classical works on north Alaska, a large heated swimming pool.

A bush plane fitted with both floats and wheels was on twenty-four-hour call for Nunamiut fishing and caribou-scouting parties, and the U.S. Park Service was represented by a young professional whose office and living quarters were housed in a state-of-the-art modular building. At this writing, the town has a population of three hundred men, women, and children (275 Nunamiut and twenty-five whites), and its ten schoolteachers serve all grades from preschool through high school. To this day, there are no roads to Anaktuvuk, but three scheduled airlines offer a combined total of four flights every day from Monday through Friday. The Nunamiut have arrived.

The above outline describes major episodes in the evolution of the Anaktuvuk Pass settlement over the past fifty-odd years. It is hardly an exhaustive summary nor does it contain the social scientist's usual captivating interpretations of how these events have affected Nunamiut culture and ethos. The facts are simply that traditional Nunamiut society no longer exists.

Nothing will bring it back, and even if a return to the old ways was possible, neither big government nor the people themselves would allow it. Still, we recall, quite romantically we admit and from a foreigner's perspective, such times as when, with a Nunamiut hunting partner, we roasted caribou ribs over a tundra fire while our pack dogs sat around us waiting for the leftovers.

THE SIMON PANEAK
DRAWINGS

HOW TO COOK A MAMMOTH

These six sequential drawings describe how Paneak's people learned about *qiligrak*, the woolly mammoth (*Mammonteus primigenius*). As explained by Gubser (1965), Nunamiut oral history contains two distinct categories of ancient happenings. The first, *unipqaq*, has to do with folktales, mainly for children, such as "How Mr. Mosquito Got His Mittens," and these are taken as myth, in the same sense as the Western world's *Aesop's Fables* or *Mother Goose* stories. But the second category, *koliaqtuaq*, includes legends—accounts of what are believed to have been actual events (Gubser 1965, 28)—of which the mammoth hunt is one.

In the 1950s, to listen to Nunamiut remarks concerning mammoths was to imagine that the Old People had been just as familiar with those great beasts as with deer, and this particular story relates to one of the most notable episodes in early Nunamiut history. It is a story that has been noted in several published accounts by visitors to the Nunamiut, but here are the only graphic illustrations of that fascinating encounter.

Contrary to what the Nunamiut seem to believe, to modern Western "scientific" thought this narrative, especially its beginning, smacks of pure myth, with the mammoth descending from the sky, chased by celestial hunters and their dogs. At the same time, much of Paneak's story rings true: the great beast running toward the protective willows, the postures of men and dogs, the dogs surrounding and holding the game while the hunters come within range, the killing and butchering, and stacking the meat to keep it out of the dirt.

And there is other fascinating detail. Note, for example, how the severed skull has been dragged clear of the carcass. These are unquestionably the ways in which the Nunamiut would have actually bagged a mammoth, providing, of course, that they ever saw one in the first place. These very same techniques are precisely those with which the Nunamiut have for centuries killed such other big game as caribou and moose.

The Short Story about just (?)
Mammoths & mastedons was just shown & landed on the earth.

The man hunters out in Colville River, he grew in the hills looking for animals to come to find & killed for his family food & then the man heard a noise & watch sounds like thunder noise but is not like it is different (?) sound is long, louder & louder (?) Sound (?) like come nearer & nearer, all the time (?) Like come nearer & clear, he comes not feel for sure nights weather was fine & clear, it absolutely is different (?) see picture in next page

Kiliguak

Early man

Colville River Simon Paneak
1968

(52)

The man hunter was watch carefully & hardly saw in the air something like animals running, but it were in the air. he camp ot believe, but the big beast & running tongue, the man 2) he was grassepain 3) lay down on his belly flat he thought no one call see how 3) his heart was beaten fast but he still time writh the get on heart running. Come closer at all the times & pretty soon, he some deep running behind the beast big animals 4) he saw some very running in the air & carrying, speak 5) gotten lower & lower chase. The big animals 6) he was saying hi! man! why not come the us-fellow us & second man do the same thing all the times 7) first man was curly the air 7) told early man the beast is tired ony dogs run down its belly to last run-all the down man curly the air is uptight now as we wish 8) the animals 9) you may have shar with us 8) the early man can't hardly breath the air. Do not be scared, come & follow me was got up from his laying on the ground (perhap all the guys wish to told him.

See other picture in next page.

← Early man was laying on the ground & hid

Big animal first landed & came & the track →

(23)

The early man was watching the hunter man throw spear to big beast & killed it early man & behind & what a man was had promised & walk down to unknown hunters & The unknown man is nice & smiling & watching the big Animals & the Unknown hunty & told him to get a fire wood for cooking. when we will have good fresh meat and & the early man think the meat so must be good to eat & the elder.

See picture in next page.

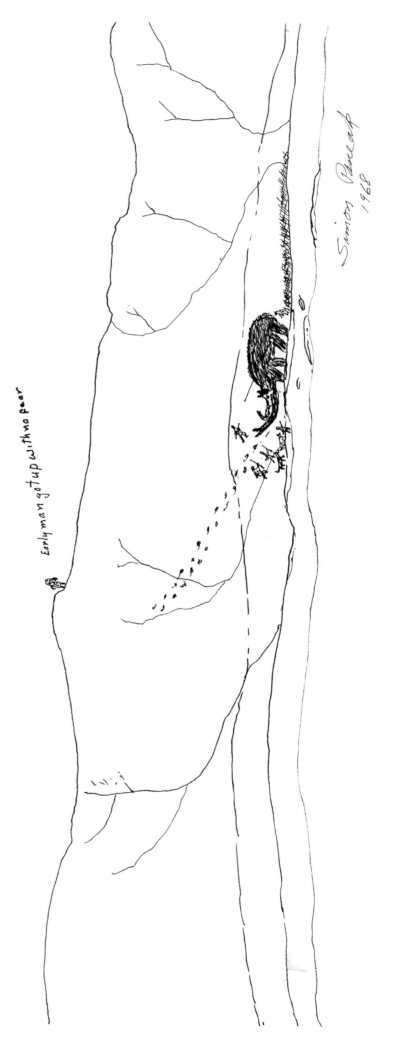

Early man got up with no fear

Simon Peacap
1968

Where, however, did Paneak get his remarkable knowledge of the looks and behaviors of woolly mammoths? (On all available evidence the last of them became extinct about four thousand years ago [Vartanyan, Garutt, and Sher 1993].) In part, his knowledge derived from firsthand acquaintance with mammoth bones and tusks, which in Nunamiut territory wash out of riverbanks.

Then, as we have described, Paneak was literate. Over the years he saw copies of popular magazines from which, one assumes, he had read about mammoths or at least had seen artists' renditions of how they had appeared when alive. Additionally, beginning in the late 1940s, he became acquainted with several visiting anthro-pologists, biologists, and geologists, and his references here to *early man* (an archaeological term) came either from his readings or from his scientist friends.

The early man down from where he was up in
the ridges kill⁹d he watching the Unknowns hunter
when a attacking big beast with throw spears &
killing the beast in near Willow patch

see other picture in next page

Early man walk down from hill -
down to unknown hunter

In first early man was collect very dry dead woods the man
of Unknowns hunter try to built fire but wont work⁹d unknows
hunter was told him go back & pick wet & wet rotten woods that
could be work⁹d early man did⁹d get wet rotten wood s⁹d unknows
hunter replaced dry wood with wet wood & fire⁹d flame goes on very good⁹d
since that times common peoples named wet rotten wood
Kiligviogutiksrak - is for malmⁱⁱth cooking fire wood, when a wood are wet &
rotten.

see pictures in next page.

Dry Wood
for repack

Early man
Pack Wet & rotten
Wood

Simon Paneak
1968

But is it possible, even most remotely, that within the past several centuries, say a thousand years or less, mammoths managed to survive on the tundra of far northern Alaska? The collective scientific answer to this question is *no, almost certainly*, but biologists and geologists (who are experts in such matters as mammoths) stop short of saying *no, absolutely*, for, after all, no one really knows. In any case, where else but among the old-time Nunamiut could you ever hope to find a rollicking good shaggy mammoth story?

(26) The early man was watching & learning how to cook
marmots meat from unknown hunters. 1) They had a very good dinner they
had 2) the unknown hunters told the early man. we take little meat
with us 3) you or you or you would they rest of the meat
all yours we would not be back but we will go back
to our ours country 4) soon after they told in day 5)
very nicely to early man & awhile 2 walk up, me the air 6)
In early when man watch & see the unknown hunters & walk up
they air install completely disappear 7) The unknown hunters
there not show after that time 8) the early man took some fat meat
to his own people being anyway 9) he told all about had seen 10)
to 11) the fire after already what the unknown hunters given 12) plenty of meat 13)
go ahead & come fallow 14) the made fall 15) the cenatic found in drying of meat 16)
tell him exactly what they man had seen 17) plentiful more marestme or share meat 18)
air come I'm & among skinnings hunt system of corner (probably unknown 19)
hunters told the early man twisted things) according to story teller
were saying. Told end of the old story

Simon Paneak
1968

PLATE 7

THE FLYING WHALE

"The Flying Whale" story, also believed to be true, is even more marvelous than that of the mammoth descending from the sky and equally prominent in Nunamiut oral history. Unlike the mammoth account, however, the Flying Whale contains little in the way of what we moderns would consider credible realism.

Except for its wings and their holes (visible in another of Paneak's whale drawings) the whale itself is realistic enough. The positioning of its eye and mouth is correct, and the shape of its back and the positioning of its wings (where pectoral fins belong) suggest that the story may relate rather specifically to the humpback whale (*Megaptera novaeangliae*). The humpback, which can be fifty feet long, has pectoral fins nearly one-third its length.

(28)

Koptojak - flying whale can be heard from long away off - sharp whistle from wing hole

Early peoples knew how to bring the whale down to ground. when the flying whale flung by close by all the peoples made a noise in loud noise ever children can screamed & soon flying whale hear the noise of peoples he get nervice lost his power & landed on the ground (can never took off the ground again) then peoples killed by spear (harpoon) arts ax's) flying whale is still killable except plenty meats. Mukluk an among Eskimos saying in early days was waiting for flying whale & watch in every days & night because big mammals is large of food for many peoples & this is short story. - end

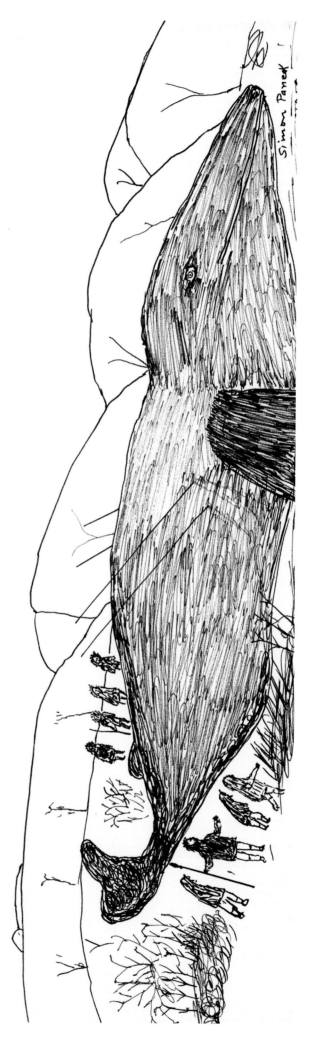

PLATE 8
THE THREE BROTHERS

This story, another *koliaqtuaq* tale, is a marvelous epic, a sort of Nunamiut Odyssey in which three strange and extraordinarily powerful and physically strong brothers have, one after another, incredible adventures across thé top of Alaska, from the Killik River and beyond to Shishmaref.

They fight, and for the most part vanquish, both human enemies and giant people killers. The brother Kovravak, having webbed hands like "a goose foot," was naturally attracted to water and once was nearly swallowed by an enormous fish. Ilagannik eventually was killed by his wife, with a jade adz no less, for sleeping with his own daughter. Aksik died, finally, from the arrows of the Kingikmiut, cowards who shot him in the back and, in turn, died by the blade of his *kayak* paddle before he succumbed. For pace, if not plot, it is one of the very best of Nunamiut *koliaqtuaq*.

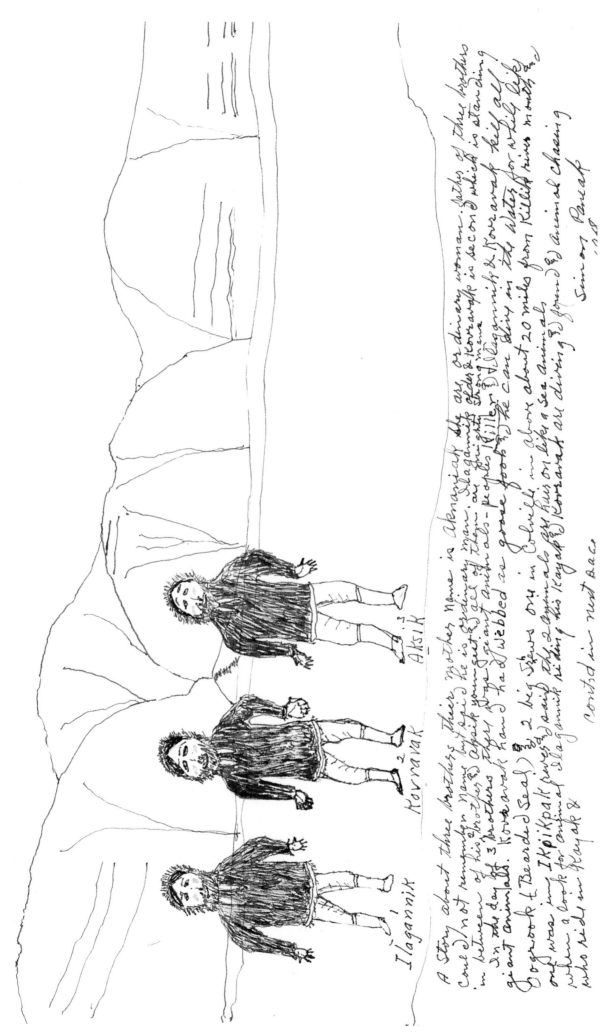

Ilagannik Kavravak Aksik

A story about three brothers. Their mother name is Akrayiaq
and not remember. Now but said he is ordinary man. Ilagannik
in between of his brother's. Aqaito youngest of them. In standing
In the day lot 3 brothers they by giant animals - peoples Killer
giant animals. Kavravak had a webbed on gone foots to be water for wild life
Boqnook (Bearded Seal) 3 & 2 big spurs on in Colville in about 20 miles from Killcliff runs months on
on was in Ikpikpak rivers by saying this 2 animals put furs on like a sea animals
when a boat for animal. Ilagannik riding this kayak & Kavravak on driving & food & animal chasing
who ride in kayak &

 Simon Paneak
 1968

contid in next page

THE FIRST MOSQUITO FAMILY

Mosquitoes in their legions were a chronic, unhappy part of summer life for both humans and dogs. We remember well Nunamiut dogs asleep with their front paws covering their eyes and their tails tucked between their hind legs. But dog or man, to endure north Alaska mosquitoes demands, in addition to practical measures, a philosophical frame of mind. "The First Mosquito Family" is one of several children's stories designed to impart an understanding attitude toward the little insects.

Without further illustrations, the story goes on from these two drawings to describe the mosquito children being released by their parents to tour the world while being cautioned to keep away from such deadly hazards as oily things and fire. The children return in mid-August after having lost numerous of their brothers and sisters who had not followed their parents' advice.

Mr.

Parent of all mosquitoes
are discuss all about problem
To thienbunch of childrens in early of June
apten had them in all winter long
in special room they had for store. cannot
go out during cold weather winter month
Too cold for you kids Mrs.

Simon Paneak
1968

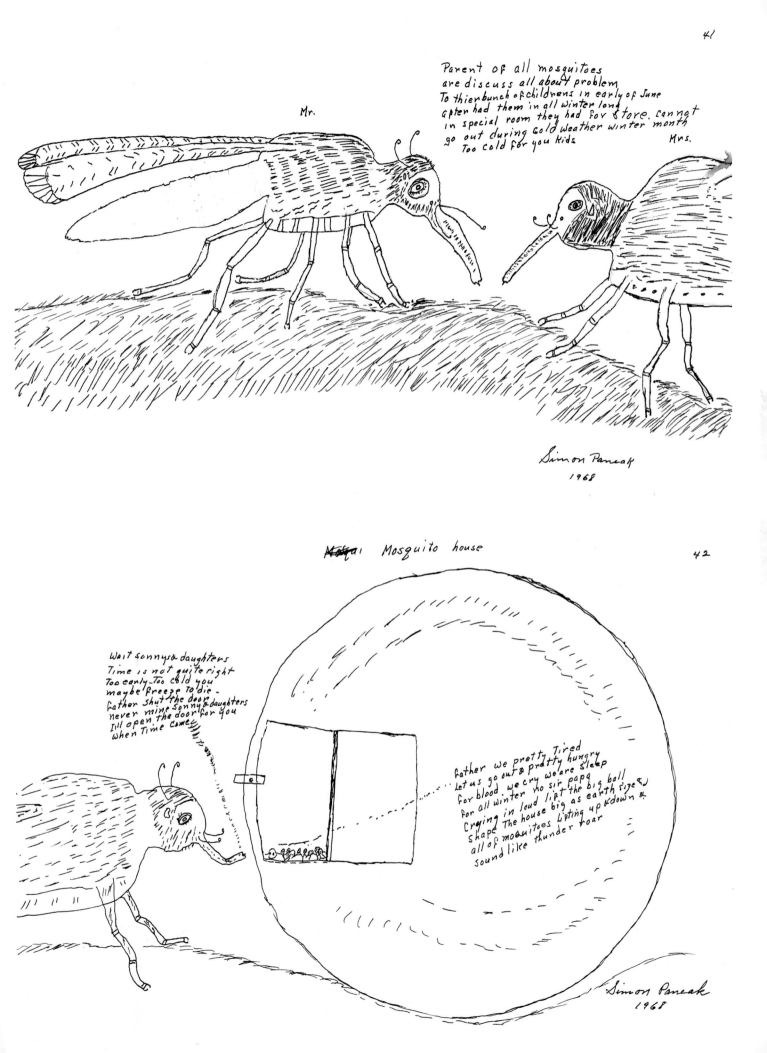

Mosquito house 42

Wait sonnys & daughters
Time is not quite right
Too early. Too cold you
maybe freeze to die -
father shut the door
never mine sonny & daughters
Ill open the door for you
when Time come

father we pretty Tired
Let us go out & pretty hungry
for blood we cry we are sleep
for all winter no sir papa
crying in loud lipt the big ball
shape The house big as earth size &
all of moszuitoes Lipting up & down &
sound like thunder roar

Simon Paneak
1968

PLATE 11
MAKING FIRE

Aboriginal bow drills, for fire making and for drilling holes in hard materials such as bone and antler, are of such antiquity and are so widely distributed across the globe that no one knows where they originated. The Eskimos used them for both purposes, but in the Arctic fire making was by far their more important function.

Most Eskimo tribes lived on treeless coasts and islands, where without seal oil and seal-oil lamps they could not have survived. For the inland Nunamiut, seal oil was a luxury to be used typically as food, not as fuel. But the only "trees" in most all of Nunamiut territory were diminutive willows that, in order to burn properly, had to

be cut months ahead of time and left to dry. These little sticks provided the fuel of Nunamiut survival. Thus, both on the Arctic coast and arctic tundra the bow drill was a tool of most extreme and critical value.

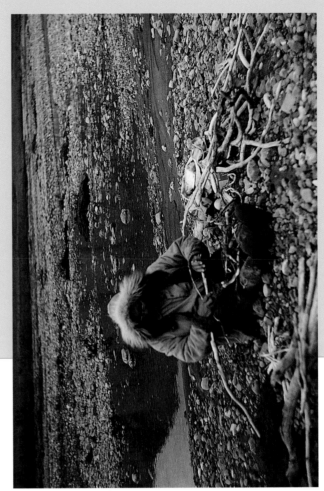

On first meeting Elijah Kakinya in 1956, the two of us walked twenty miles, most of them in a steady rain, over a tundra landscape that offered practically nothing in the way of firewood. In fording the Anaktuvuk River, however, we crossed a gravel bar containing a few wet willow sticks carried down in flood. Shaving them to their inner dry wood, it took Kakinya less than ten minutes to boil a pot of tea, during which, in a language I did not understand, he talked of his family. Photograph by the author.

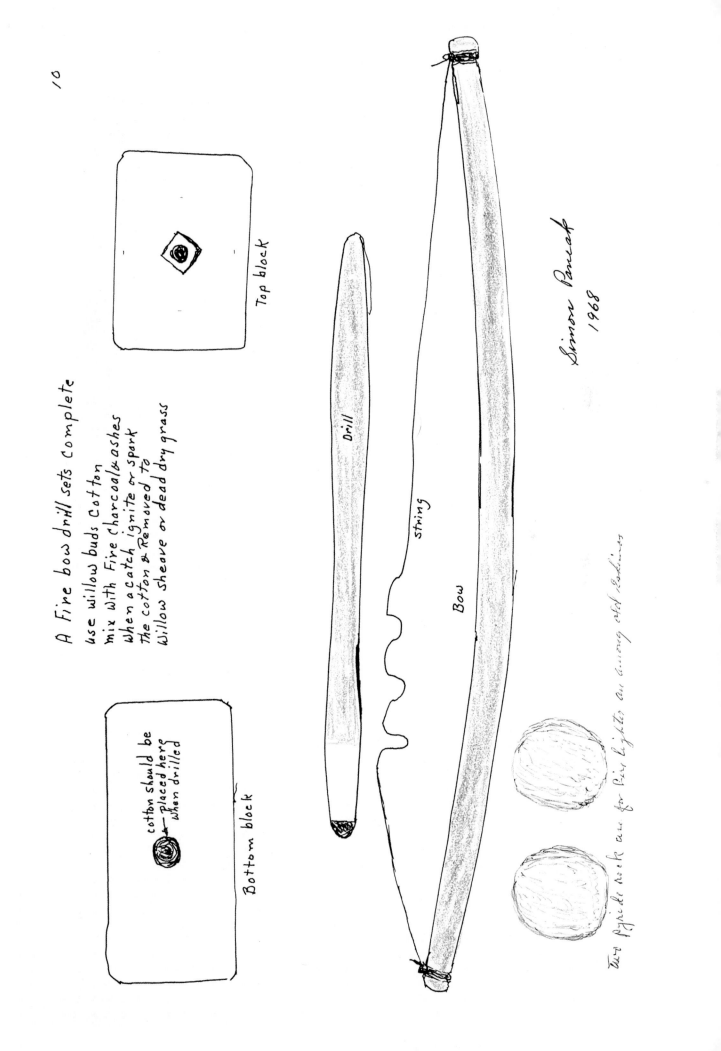

A Fire bow drill sets complete

use willow buds Cotton
mix with Fire Charcoal & ashes
when a catch ignite or spark
the cotton & Removed to
Willow Sheave or dead dry grass

Top block

Bottom block

cotton should be placed here when drilled

Drill

string

Bow

Simon Paneak
1968

Two Pyrite Rock are for Fire lighter are among old Eskimos

PLATE 12
MEN'S WINTER CLOTHING

Cold climates require highly sophisticated clothing, and for lightness and warmth traditional Eskimo cold-weather clothes were reputedly the best on earth. However, that they were made of wild animal skins and demanded constant maintenance prevented their adoptions by such interested organizations as the U.S. and Soviet armies.

Styles varied from tribe to tribe but throughout the Eskimo area the principle was the same: an outer layer, with the hair side turned outward, and a full suit of underclothing, with the hair next to the wearer's skin. Each winter outfit was tailored quite precisely to the individual's dimensions, whether toddler or adult. Nunamiut men provided the skins, and Nunamiut women did the tailoring. In this drawing, Paneak describes a man's under-suit, complete except for mittens. Note that the hood of this inner parka contains only a short ruff; numerous such hoods contained no ruff at all. Not shown here and in plate 13 is the critically important outer ruff (plates 46, 47–48).

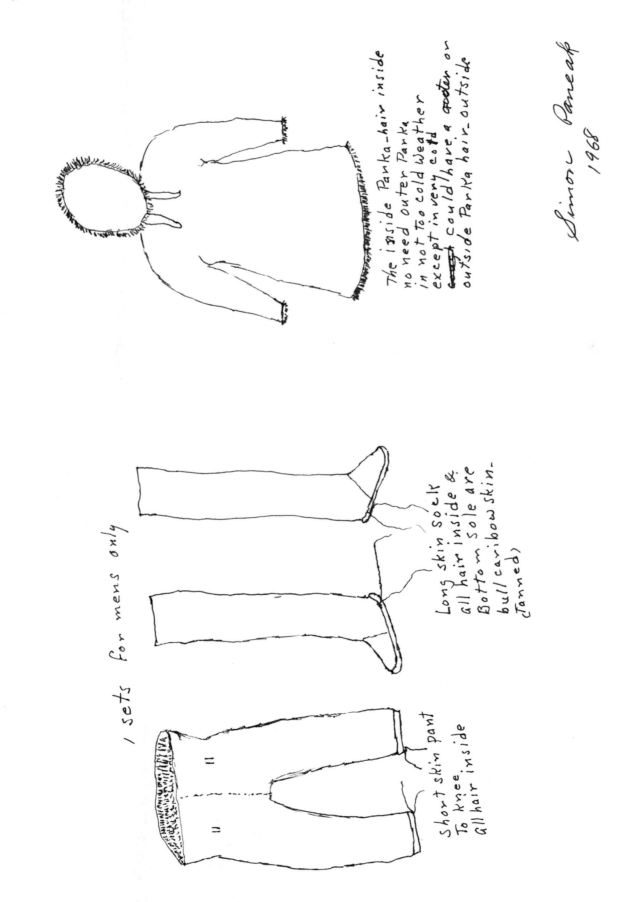

The inside Parka-hair inside
no need outer Parka
in not too cold weather
except in very cold
~~except~~ could have a geater on
outside Parka hair-outside

Simon Paneak
1968

I sets for mens only

Long skin sock &
all hair inside &
Bottom sole are
bull caribow skin-
(Tanned)

Short skin pant
To knee inside
all hair inside

PLATE 13
WOMEN'S WEAR

While in some Eskimo tribes women's and men's winter styles varied notably, among the Nunamiut differences were mainly in the short woman's apron (much elaborated and embellished in some tribes of eastern Canada and in Greenland) and in the full-length women's underpants with their attached boots, as shown here. Nunamiut men's and women's winter footwear consisted importantly of the two types of inner socks, or boots, illustrated here and in plate 12, and both for reasons of fashion and extra protection in traveling or extremely cold weather, both sexes wore outer boots (not shown) having uppers of decorative caribou skin and

soles of tough, bearded seal (*Erignathus barbatus*) hide traded in from the Tareumiut. The only items of Nunamiut winter clothing that were not double-layered were the mittens of caribou skin, hair side turned inward. All clothing was expertly stitched with needles of nicely worked bone slivers and thread of caribou sinew.

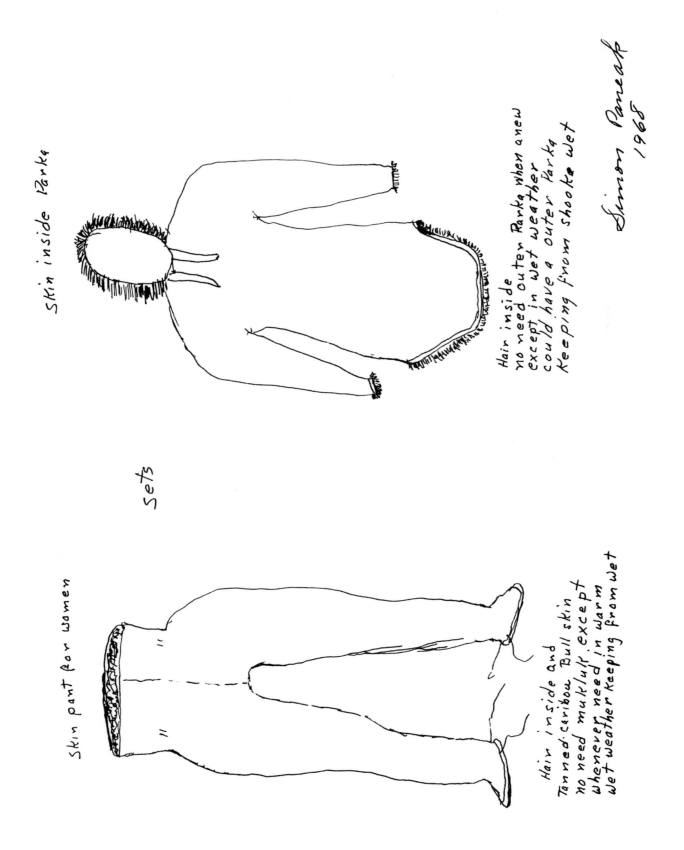

44

Skin inside Parks

Hair inside
no need outer Parka when anew
except in wet weather
could have a outer Parka
Keeping from Shooke wet

Simon Paneak
1968

sets

Skin pant for women

Hair inside and
Tanned caribou Bull skin
no need mukluk except
whenever need in warm
wet weather keeping from wet

PLATES 14-15
THE HEMISPHERICAL TENT

Portable or temporary houses are part of the hunting way of life, and the two main Nunamiut dwelling types reflect examples of each. The hemispherical, caribou-hide tent (*itchalik*) was easily erected and just as easily taken apart for transport to a new location. In 1956 we witnessed the construction of one of the very last of these houses, although it was smaller than usual and built by a young Nunamiut hunter especially for his bride-to-be.

An *itchalik* of ordinary size was framed in twenty or more slender and flexible willow poles and covered with about the same number of caribou hides sewn together with their hair sides turned outward. For weather proofing, another layer of sewn hides, with hair removed, was sometimes added as an outer covering. These two drawings show in detail how the frame was built. Note that the tips of twelve poles have been tied together to create the six major hoop-shaped members.

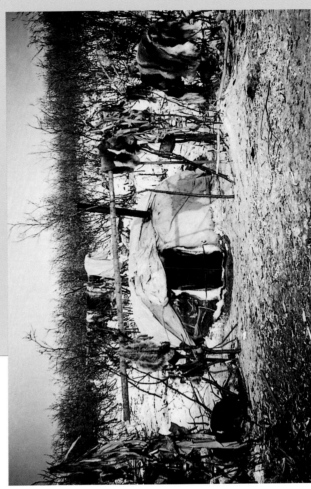

This photograph by Robert L. Rausch, the first zoologist to work in central Nunamiut territory, was taken in one of the last years in which the typical hemispherical tent remained in common use. At forty degrees below F the traditional Nunamiut itchalik, built of bent willows covered with caribou hides, was as good as anything modern engineering has yet to come up with. The white man's stove and stovepipe are only embellishments on a superb native design. Photograph by Robert L. Rausch, 1950.

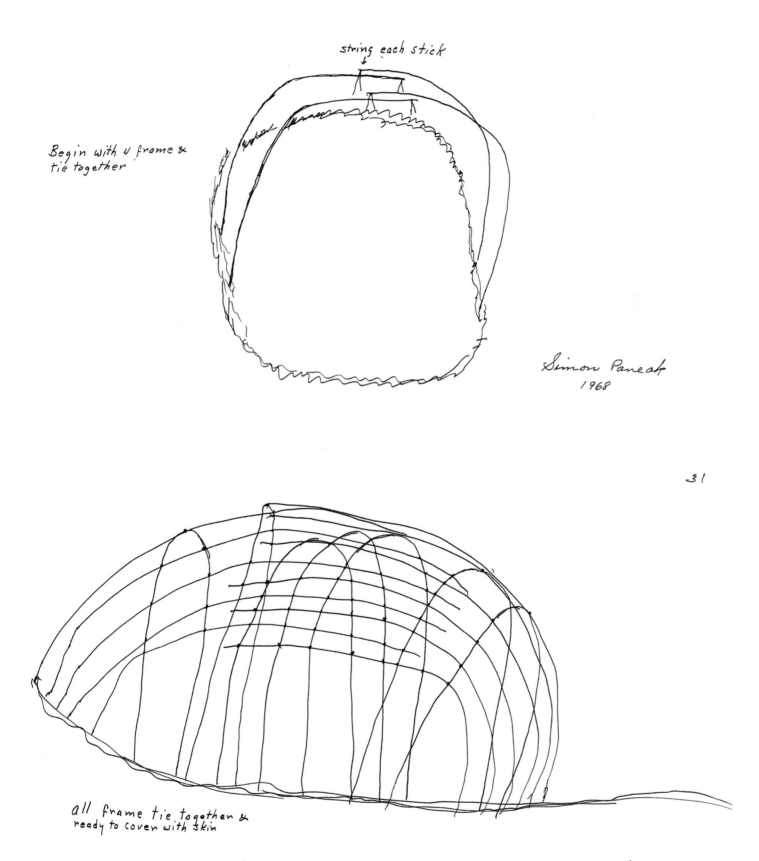

string each stick

Begin with u frame &
tie together

Simon Paneak
1968

all frame tie together &
ready to cover with skin

Simon Paneak
1968

PLATE 16
A FINISHED *ITCHALIK*

Used both summer and winter, the *itchalik* was the principal Nunamiut house. Until the advent of the white man's metal stove, cooking was accomplished over an open hearth, either within or outside the tent, depending upon weather. In summer, both before and after the coming of the stove, a mosquito smudge was commonly kept burning in the doorway.

In winter, snow and earth shoveled against the outer wall at ground level, combined with caribou hide rugs and a small interior fire, resulted in a snug winter house. Rausch (1951), in producing the best published account of the *itchalik*, remarks that the circular or oval floor was about twelve feet in diameter; ceiling height was five to six feet; and that it took twenty caribou hides to cover the dwelling.

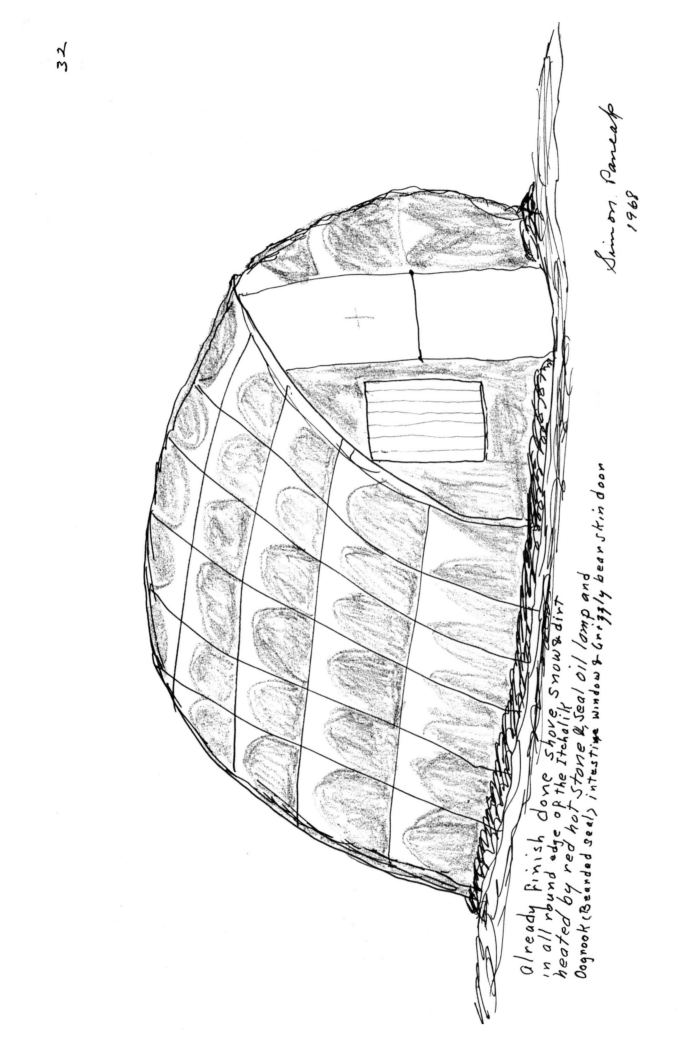

32

Already Finish done shove snow & dirt
'in all round edge of the Itchalik
heated by red hot stone & seal oil lamp and
Oognook (Bearded seal) intestine window & Grizzly bear skin door

Simon. Paneak
1968

PLATE 17
A MOSS HOUSE FRAME

The *ivrulik* (moss house) is con-fused commonly with the sod house whose Nunamiut history is opaque and which may have been an early- to mid-twentieth-century innovation. An *ivrulik* was a surface dwelling essential-ly, but its hexagonal plan and short entrance passage attest to an ancient circumpolar design.

Nonportable, it was inhabited for a single winter only, and its use required both abundant sphagnum moss and the on-site availability of robust willows.

In this drawing, Paneak describes the first steps in its framing. Its posts, excluding those of a short entrance pas-sage, were six feet tall, four to six inches in diameter, and foot-ed on a gravelly surface cleared

of mosses, lichens, and other vegetation. Freshly gathered sphagnum provided an under-floor whose surface was then covered with several hundred narrow willow withes.

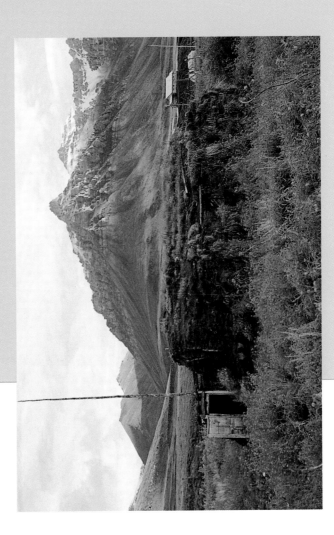

By the mid-1950s, traditional Nunamiut skin tents and moss houses had been replaced by canvas tents for sum-mer use and rectangular winter dwellings of sod framed in stout willow or spruce poles. The origins of this house type are unknown, but among the Nunamiut it seems to have been a modern innovation or introduction dating no earlier than the 1940s. Photograph by Thomas H. Follingstad, 1959.

12

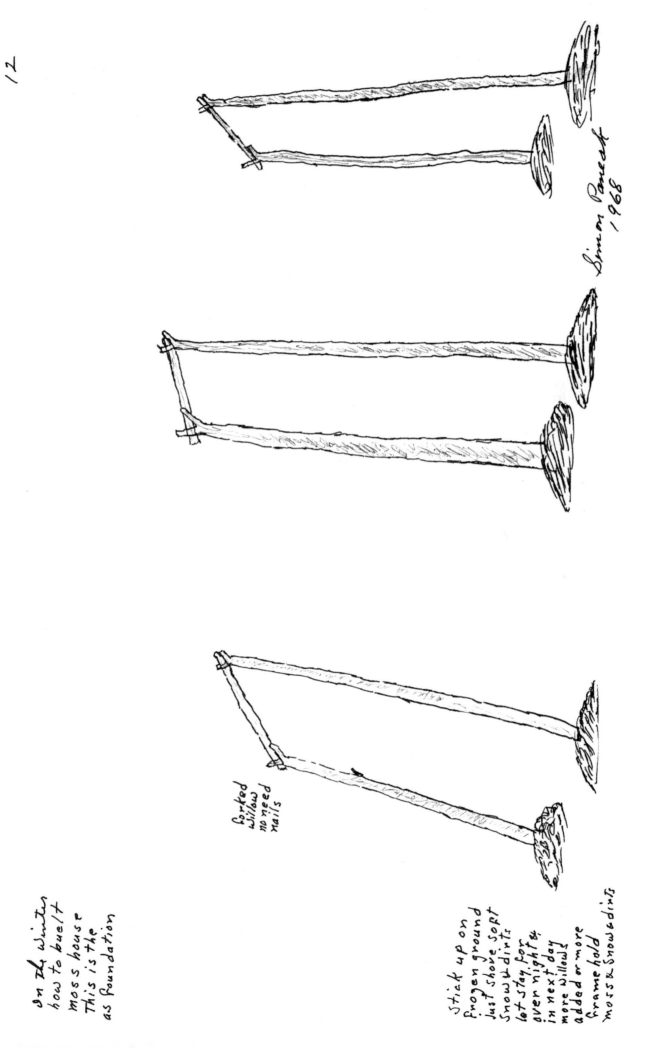

In the winter
how to buelt
moss house
This is the
as foundation

Forked
willow
no need
nails

Stick up on
frozen ground
just shove soft
snow & dirt,
let stay for
over nights,
in next day
more willows
added or more
frame hold
moss & snow adding

Simon Paneak
1968

PLATE 18
A FINISHED *IVRULIK*

This is not one of Paneak's best drawings; nevertheless, except for the entrance passage, which is given short shrift, it is about the way an *ivrulik* looked and his annotations are instructive. The skylight window was made of the intestines of the *Oogrook*, the big bearded seal traded from the coast.

Once framing was complete and the willow withe side and roof members were laid on, the house was covered with a layer of sphagnum moss to a depth of eighteen inches. In some localities this moss is so thick and dense that a family could apply the covering in less than an hour. The moss is adhesive; thus, it holds down the withes and requires no tying or paneling. A few rocks or caribou or sheep skulls were thrown on the roof to protect it from wind.

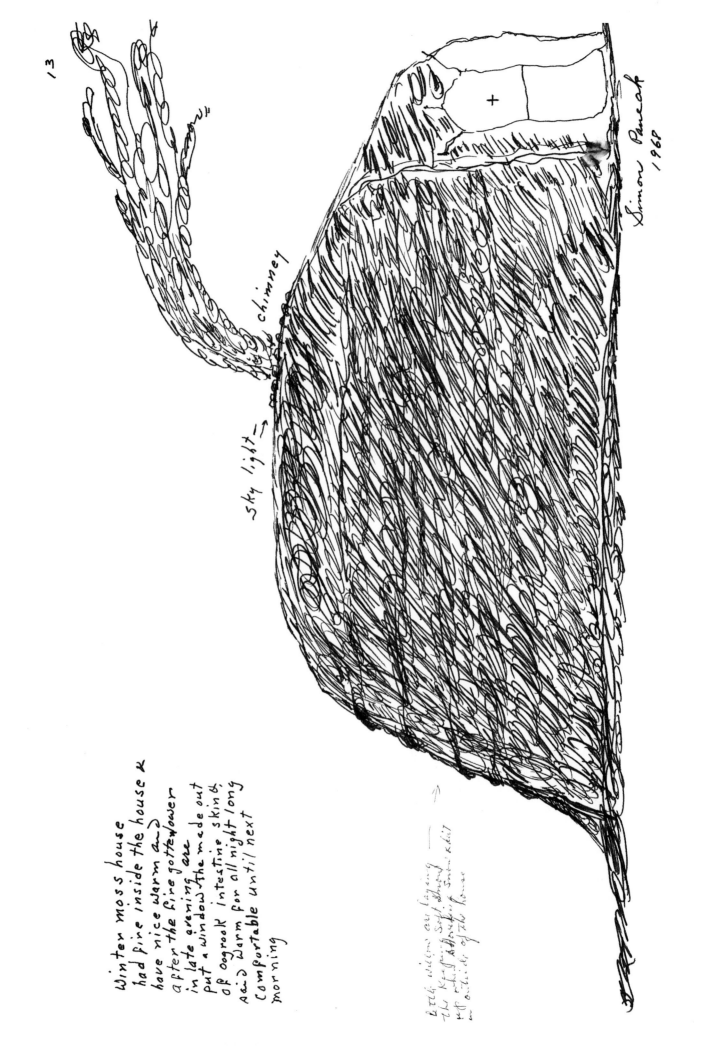

13

Winter moss house
had fire inside the house &
have nice warm and
after the fire gotten lower
in late evening are
put a window the made out
of oogrook intestine skin,
said warm for all night long
comfortable until next
morning

birch willow or laying
the ... soft along
... about
... outside of the house

chimney

sky light →

high ?

Simon Paneak
1960

PLATE 19
SAILING UP TO NIKLIK

Niklik was one of the most celebrated gathering places in all of the western Arctic. Members of numerous bands from sometimes three or more Eskimo tribes assembled here briefly in summer, not only for trading but also for oratorical presentations, athletic events, dancing, and romance. The Nunamiut brought flints and gyrfalcon feathers from the sedimentary bluffs and rocky outcrops of the upper Arctic Slope. They traded these, and products of the northernmost forest, for such saltwater luxuries (among others) as seal oil and skins and the meat and blubber of seals and whales.

This drawing shows a little fleet of Point Barrow (Tareumiut) umiat (plural of umiak) arriving from the sea on a rising tide and a following wind. As far as is known, the crab-claw sail is not native to North America but is common among Pacific Islanders and was presumably introduced to Alaska sometime following first Russian contact in the early 1700s.

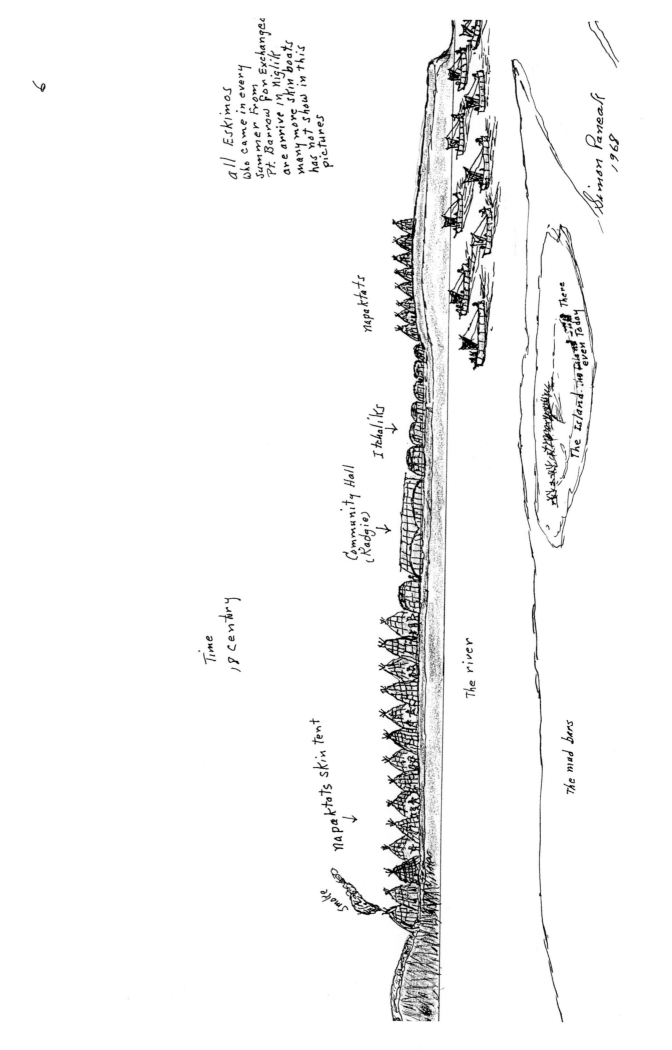

6

all Eskimos
who came in every
summer from
Pt. Barrow for Exchanges
are arrive in niglik
many more skin boats
has not show in this
pictures

Simon Paneak
1968

Time
18 century

Napaktats skin tent
↓

Smoke

Community Hall
(Kadgie)
↓

Itchaliks
↓

Napaktats
↓

The river

The mud bars

The Island. The Island is still There
even Today

PLATE 20
THE CONICAL TENT

Niklik and its environs offered practically nothing in the way of food or willow fuel for cooking. Consequently, the people brought their food and firewood with them, and when these gave out, the after a week or two at most, the meetings were adjourned. Similarly, the people brought their houses, prefabricated structures of ages-old design, and carried them home again when the rendezvous was over.

Shown in plate 19 are examples of the typical Nunamiut hemispherical tent (*itchalik*) of sewn caribou hides over a bent willow frame (plates 14–15, 16). Second is the big, hide-and-willow *kadgie* (as Paneak spells it), not a dwelling but, as Paneak explains, a "community hall."

And third is the *napaktak* (plural *napaktat*) illustrated here and in plate 21. It is a conical, tepee-like dwelling, again covered with hides, but mentioned seldom in published accounts of Arctic Alaska, where it is said to have been a coastal Taremiut summer house (Murdoch 1892, 84–86; Nelson 1899, 261; Ray 1885, 38–39).

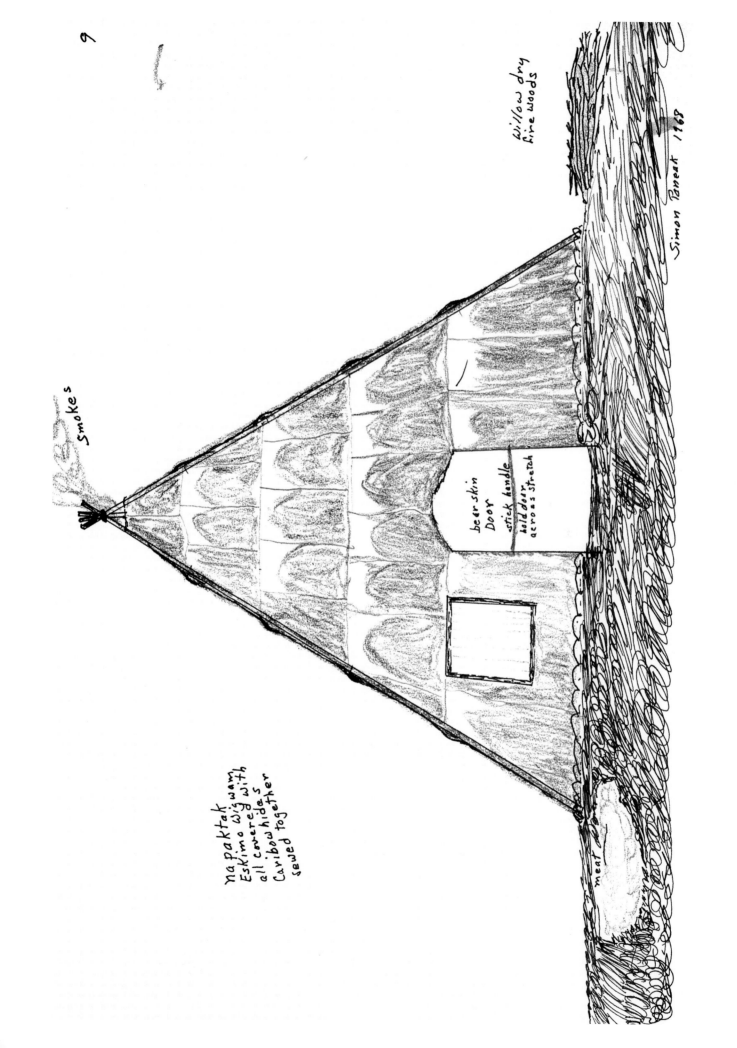

9

willow dry
fine woods

Simon Paneak 1968

Smokes

bear skin
Door
stick handle
hold door
across stretch

napaktak
Eskimo Wigwam
all covered with
Caribow hides
sewed together

meat

PLATE 21

A *NAPAKTAK* FRAME

Paneak refers to this dwelling as belonging to the "18th century." However, given his detailed knowledge of its architecture he must mean the 1800s. That it survived until at least the late nineteenth century is witnessed by illustrations in Murdoch (1892), Nelson (1899), and Ray (1885), as cited in the previous plate text, although their examples seem smaller and more makeshift than the imposing structures shown here and in plates 19 and 20. In any case, Paneak's drawings are by far the best-known illustrations of the illusive *napaktak*.

Assuming that the height of its door was similar to that of the *itchalik*, about five feet, one estimates that the typical *napaktak* was fifteen to seventeen feet tall with floor diameter as large or larger than its height. Although shown vertically in this drawing, the stone-lined fireplace undoubtedly lay horizontally on a low bench.

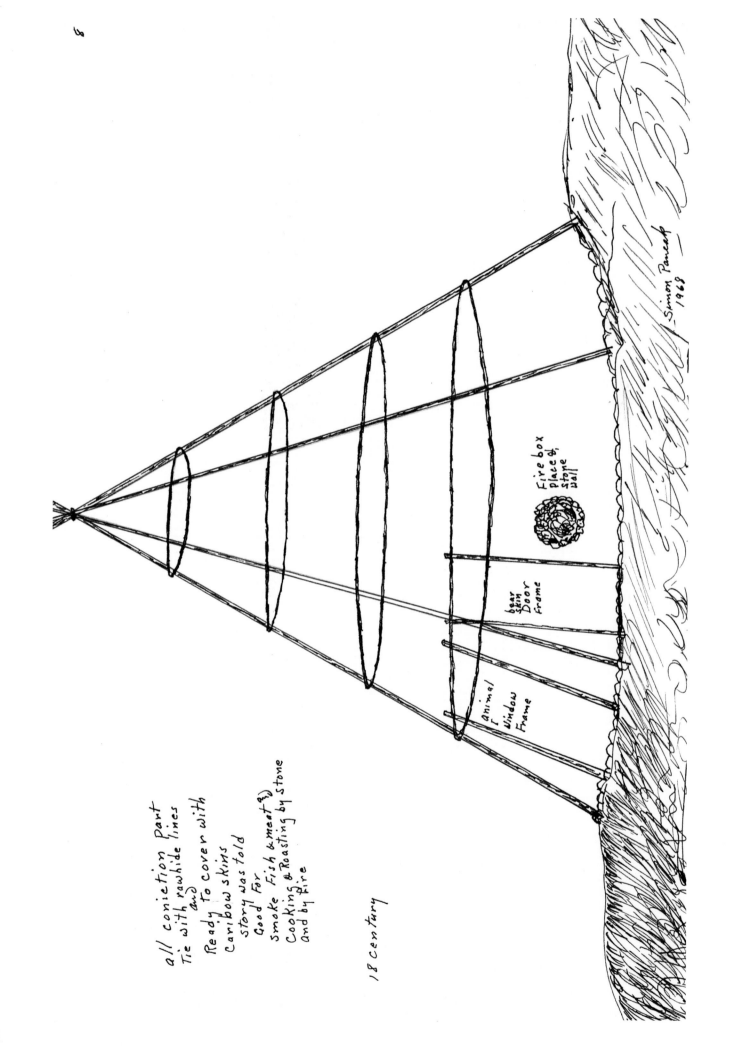

all coniction Part
Tie with rawhide lines
(and)
Ready to cover with
Caribow skins
story was told
Good For
Smoke Fish & meat (?)
Cooking & Roasting by Stone
And by Fire

18 Century

bear
skin
Door
Frame

animal
[
window
Frame

Fire box
place &,
stone
Wall

Simon Pancent
1968

SNOW HOUSE

The famous Eskimo snow-block *igloo* of children's story and cartoon fame was restricted mainly to the Canadian Arctic, where in its marvelously domed form it was built on winter sea ice. The snow house shown here, an *apuyaq*, had nothing to do with the classical Canadian structure but instead was built, as Paneak explains, by shoveling, piling, and heating soft snow.

Occupied for only a night or two, and by no more than one or two people, it was a traveler's shelter. While it smacks of the makeshift, its actual sophistication is instructive to all moderns who wander a snowy wilderness in the dead of winter. Note the snow door with its latch string and the vent in the roof, the latter of which will save you from killing yourself with the fumes of your high-tech stove.

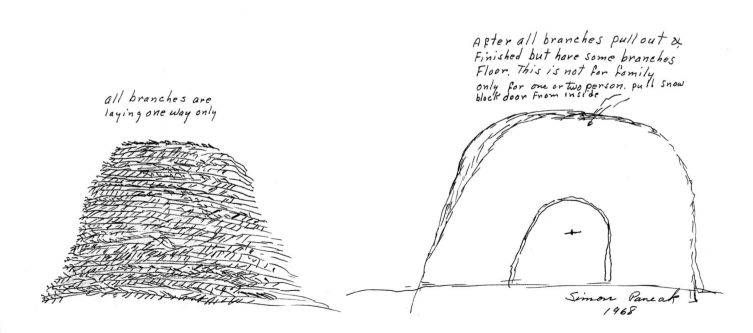

about how to make
snowhouse by soft snow
Shoveling soft snow together &
pile high enough room for
one & two persons & neat the
snow & after one hour a
start digging begining
from near bottom
use Snowshoes
as shovel when shoveling
out of the snow.
Heat some rocks by fire &
first bring unheated rock
To make a bed for Red hot
rock bring them in &
warmed in ½ hour. then nice &
warm during all night long
This is not for
Family

Little hole

How to make door
by soft snow.
Shoveling snow, together
neat down by steping by foots—
let stayed about one hour &
then loosen by stick in under
part in all round edge

Snow
Door

piece a willow stick
&
Tie rawhide lines
and
pull from inside
shut the door

Simon Paneak
1968

How to make little house
in forrest. breaking branches
of Common Spruce & pile them
up how big need the little house &
shoveling by Sno-shoes the soft snow
into over branches. neat over the snow &
let stayed about 1 hour or more all upon
the snow gotten hard & pull branches
begining from bottom ones. one by ones

all branches are
laying one way only

After all branches pull out &
Finished but have some branches
Floor. This is not for family
only for one or two person. pull snow
block door from inside

Simon Paneak
1968

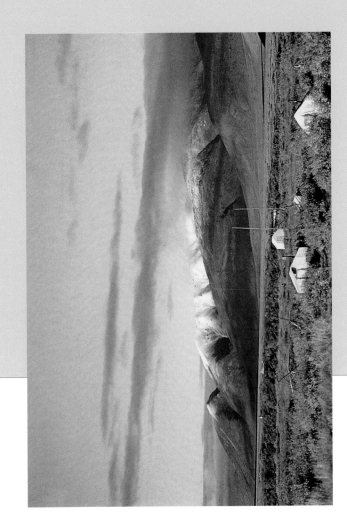

This 1959 Nunamiut encampment at the summit of Anaktuvuk Pass contained about eighty men, women, and children and twice that many dogs. The summer tents, of canvas, were scattered over an area measuring a quarter of a mile in diameter. The sled dog pups, allowed to run loose, devoured all garbage. The result was a scrupulously clean camp. Photograph by Thomas H. Follingstad.

PLATE 24

A COLVILLE RIVER ENCAMPMENT

This is the only known picture of an early Nunamiut village, and it shows faithfully the typical size of the traditional Nunamiut band. Households consisted typically of two parents and two to four children (and, occasionally, a widowed or otherwise unmarried close relative), so these seven deerskin dwellings contained a total of some thirty to forty-five men, women, and children.

The *umiat*, turned on their gunwales to dry, testify that the setting is on the lower river, somewhere downstream from the place called Umiat, the head of navigation on the Colville. The lone caribou bull, being towed ashore by the hunter in his *kayak*, has been killed, quite

possibly, by stalking rather than in a surround or water drive. Its clean, mature antlers, lacking the "velvet" of antler growth, show that this is an autumn encampment.

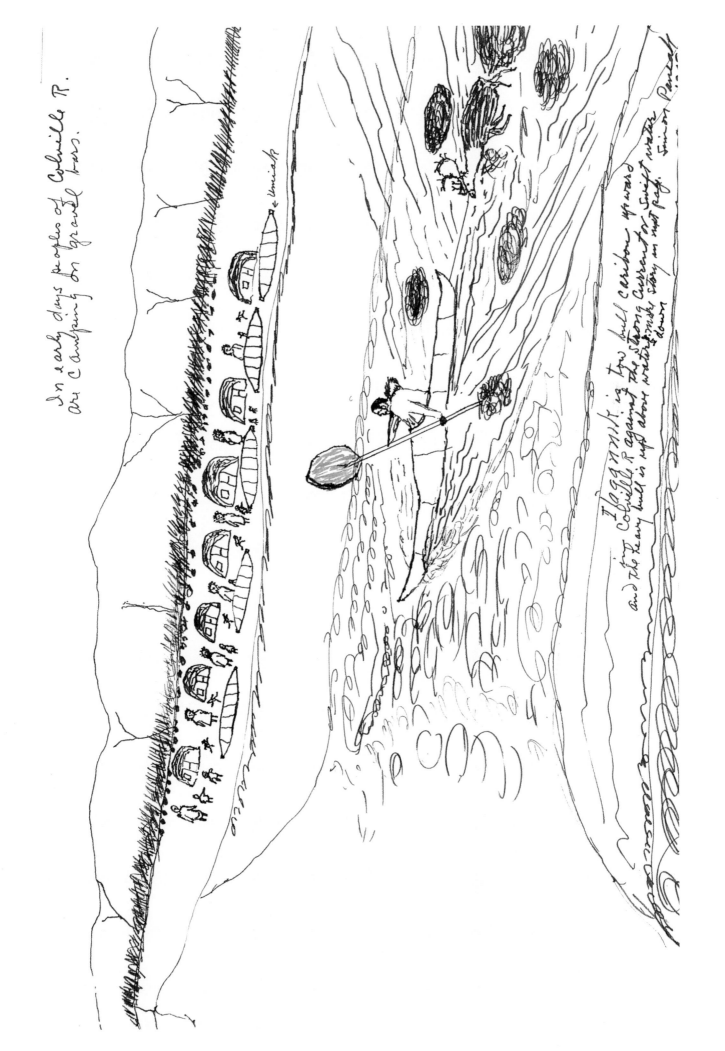

In early days people of Colville R.
are camping on gravel bars.

← Umiak?

Haggruik is low bull caribou upward
and the Colville R against the strong current upward
and the heavy bull is not about unobtrusively story in very fast water
Salmon fight water down
Snow River Panther

PLATE 25
GOOSE HUNTING WITH A BOLA

The bola (*kilamitak*) was made of several three-foot rawhide lines tied together at one end while the loose end of each was fastened through a hole drilled in a piece of walrus or mammoth ivory. The hunter held the tied ends together in his hand, swung the contraption around his head, and let it sail. Its effective range was only about twenty yards, but it could be a deadly hunting method, especially when thrown into a tight, close-flying flock. If its whirling strings did not entangle one bird, they often got another.

Among the coastal-dwelling Tareumiut and their ancestors, the bola accounted for tens of thousands of eider ducks, whose migratory pathways follow the beaches. Nunamiut territory contains few eiders, and other waterfowl are relatively uncommon. Still, Nunamiut hunters used the *kilamitak* both in duck and goose hunting and for killing the arctic grouse known as ptarmigan.

Pond

a man piled up or stick up
willows & hid & geese fly
close by he throw his kila mita &
Tangle round in wing or the bird or
Goose down

Simon Paneak
1965

89

PLATE 26
DUCK HUNTING

This drawing shows an example of a bola (plate 25) and a set or layout of duck snares. Great flocks of Arctic coastal ducks are absent from Nunamiut territory, but summering pintail ducks (*Anas acuta*) in flocks of twenty or fewer typically occupy the grassy margins of certain tundra lakes and ponds.

Probably, therefore, these baleen snares were used primarily in catching pintails. Given the small flocks, the vicissitudes of snaring, and that pintails weigh little more than a pound and a half, one concludes that this sort of duck trapping contributed very little to the Nunamiut larder. Nevertheless, as noted elsewhere, the people overlooked practically nothing that had food value.

Ķiļamitats
throw it to
flying ducks-Geeses.
bying it down by
the man

all soled horns.
Walruse Task
Ivory

Pond & lake shore where ducks & Geeses can feed
Use Whale bone - Baleen sets laying on shore of
the pond & lake catching by feet

shallow & grassy shore

Simon Paneak
1965

PLATE 27
A PTARMIGAN NET

While not one of Paneak's more inspirational pictures, this drawing introduces two Nunamiut game birds and points up a significant characteristic of the Nunamiut food quest. In order for the Nunamiut to survive, it was necessary to kill as many food species as possible in large, or relatively large, assemblages. Hence the group efforts that resulted, for example, in bagging dozens of wild reindeer in a single drive.

Kadgivik, the willow ptarmigan (*Lagopus lagopus*), and *niksaktongik*, the rock ptarmigan (*L. mutus*), are two far-northern grouse that in winter congregate in very large flocks. One can imagine the hours and days it took to make a sinew net of this size (5 by 180 feet, with five-inch mesh), but once finished it could entangle forty or fifty birds at a time. Ironically, as delicious as they are, there is little food value in ptarmigan, although, as the Nunamiut learned long ago, ptarmigan are better considerably than nothing at all.

23

4 ft deep

30 fathom long
Ptarmigan net when a stretch out
used in a snow or winter only -
drove a Ptarmigans flock into the net-
all braided sinews sin. mess
 = =
no problem how to set in willow only and
Snare for Ptarmigans in willow only and
Catching Sno-shoe hare Rabbits

Simon Paneak
1966

Although this picture was taken in neighboring Yukon Territory rather than in Alaska, it shows something of the size and weight of numerous north Alaska lake trout. The two fish held here by a Canadian schoolteacher and his son weigh thirty-three and thirty-two pounds, respectively, and are as nutritious as any game mammal. Photograph by the author, 1976.

PLATE 28
LAKE TROUT

The most important fish was *ikaluakpuk*, the lake trout (*Salvelinus namaycush*), which, as its name suggests, was restricted to lakes. Lake trout are often impressively big, and their flesh is relatively oily, thus providing necessary fat to the human diet. But of the thousands of lakes and ponds in Nunamiut territory, relatively few have the depth (forty to fifty feet or more) required by lake trout.

This fish was so valuable, however, especially in times of deer scarcity, that the main, or headquarters, settlement of each Nunamiut band was sited invariably on one of these deep, widely scattered lakes. Most *ikalu-akpuk* were caught in winter on hand lines. The unbaited lure, imitating a small fish, was of walrus or mammoth ivory three inches long and fitted with a barbless antler hook.

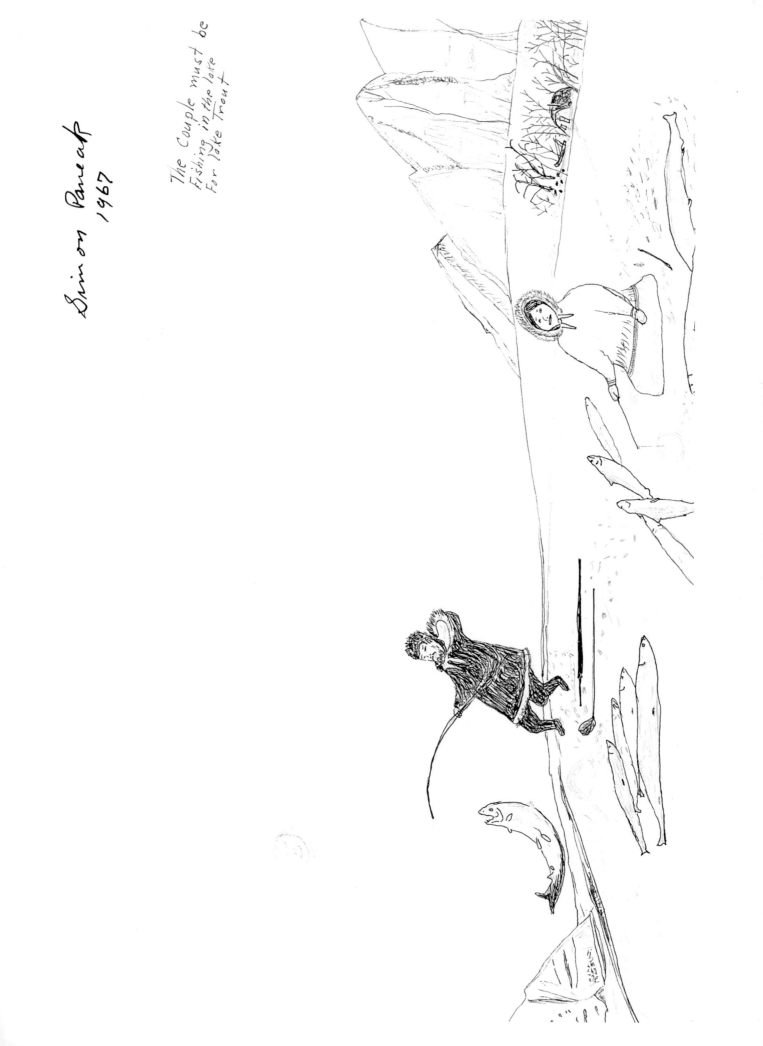

Simon Paneak
1967

The Couple must be
Fishing in the late
For lake Trout

PLATE 29
BURBOT FISHING

Tittaaliq, the burbot or ling
(*Lota lota*), is a voracious,
strange-looking fish that lives
close to the bottom of north
Alaska streams and lakes, stay-
ing out of range of arrows and
spears. In Nunamiut territory, a
good burbot may weigh more
than twenty pounds, and while
it is an all-around excellent food
fish, it was singled out further
by Paneak and his tribesmen
because of its prized liver.

Burbot will characteristically
swallow a bait, hook and all,
and for this reason they were
caught most typically on set
lines. In this drawing, the hook
(of antler apparently) is of
the ages-old traditional type.
Additionally, for *tittaaliq*, the

Nunamiut often used a gorge—
an antler sliver two inches long,
sharpened at both ends, and
buried in a piece of fish or meat.

Our 1969 Brooks Range summer was devoted largely to assessing species and relative numbers of fishes in certain unfished wilderness streams. Here, Mary Nutt is prepar-ing to weigh and measure a six-pound John River burbot, which true to its avaricious nature was caught in one of our experimental gill nets while in the act of devouring an entangled whitefish. Photograph by the author.

Hooks sets for Linc cod & Lake trout –
pike under the ice and in river bank
in deep water.
Old Timer carried 10 sets hook
when Traveling when a luck caught 10 Linc cod
a night

stick

The ice of the river

The bottom of river

5 in. length

Kajnooksak

Simon Paneak
1965

PLATE 30
FISHING THROUGH THE ICE

Here, as in caribou hunting, is
an example of food getting in
which many or most members
of a Nunamiut band participat-
ed. In fall, fish in shallow north-
ern streams often travel long
distances upriver or down to
certain pools whose depth and
current provide oxygen enough
to carry them through the win-
ter under the ice. (Some of the
fishing localities noted in plate
32 reflect these winter refuges.)
Commonly, such pools harbor
hundreds of fish, often of more
than one species, and with the
right method, and fisherman's
luck, they can be caught by the
sled-load.

Both from the drawing itself
and from Paneak's annotations,
it is obvious that these anglers

are using a gill net, a deadly
artifact whose use in aboriginal
Alaska is questionable (Driver
and Massey 1957; Rau 1884).
Possibly, it was introduced to the
American Arctic from nearby
Eurasia several centuries ago.

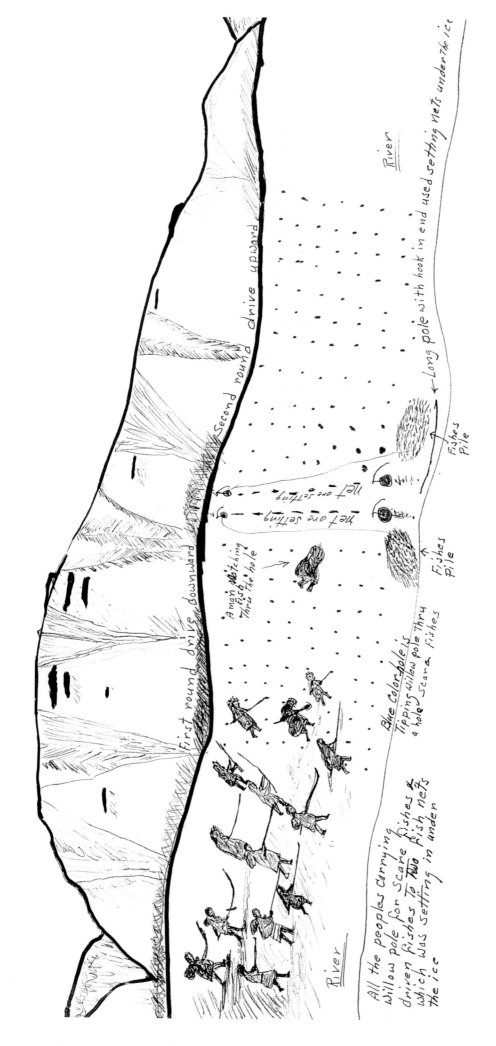

River

First round drive Downward

Second round drive upward

River

Net one setting

Net one setting

Fishes Pile

Fishes Pile

Aman watching fish thru the hole

Blue color hole is
Tipping willow pole thru
a hole Scare fishes

← Long pole with hook in end used setting nets under the ice

River

All the peoples carrying
Willow pole for scare fishes &
driven fishes To Two fish nets
which was setting in under
the ice

Simon Paneak
1967

PLATE 31
ONE HUNDRED POUNDS OF FISH

At certain favorable localities, hook-and-line fishing could be nearly as productive as the usual Nunamiut methods by which important food animals were killed collectively rather than one at a time. In fact, fishing with hooks and catching ground squirrels in snares were the most productive exceptions to the general rule of large-scale collective capture. This family has camped beside a river pool containing both *tittaaliq*, as previously described, and *siilik*, or northern pike (*Esox lucius*).

To keep them from spoiling the fishing, the sled dogs have been tied beside the tent (marked by a plume of willow smoke), and for the same reason the two children have been per-

suaded to play on the bank. The fish, frozen rock solid, will provide sustenance for days to come. The pike being caught are not fat, and so in this season of prosperity they will be fed to the long-suffering dogs.

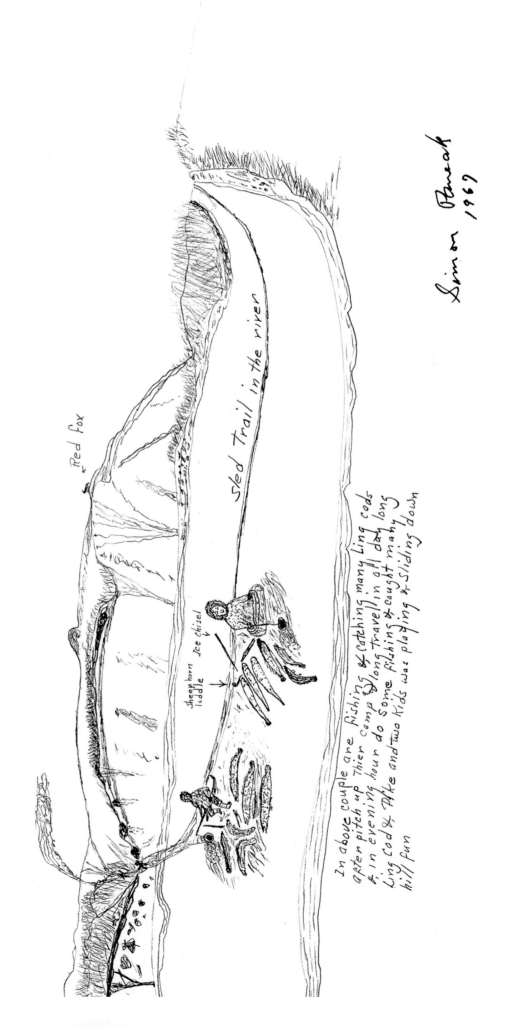

Red Fox

Sled Trail in the river

Sheep horn ladle

Ice Chisel

In above couple are fishing & catching many Ling cods
after pitch up thier camp & in evening when do some
& in evening when do travell in a day long
Ling Cod & Pike and two kids was fishing & caught long
hill fun

Simon Pancak
1969

This photograph—where the Arctic begins—was taken a moment or two after flying over the last of the spruce trees in the upper valley of the John River. Beneath our aircraft, a pontoon-equipped Cessna 180, the river's floodplain contains only small willows and alders. From this place northward to the sea, for more than two hundred air miles, it is an exclusively tundra landscape. Photograph by the author, 1958.

PLATE 32
A FISHERMAN'S MAP

We have noted that without the caribou Nunamiut territory would have been uninhabitable. Although the same cannot be said for any other single animal species, without several fishes prolonged or "permanent" human settlement would have been equally impossible. In other words, caribou hunting was essential to survival but so was fishing.

Fourteen known fish species occur in the Nunamiut homeland, six of which were critically important, most particularly in times of caribou scarcity. Five of the six occupy both rivers and lakes, and in this drawing Paneak describes traditional fishing localities in a total of ten north-flowing streams.

His cartography is remarkably accurate, the more so because when he composed this drawing most of the rivers and creeks shown here were unnamed on published maps and some were placed inaccurately or were missing entirely.

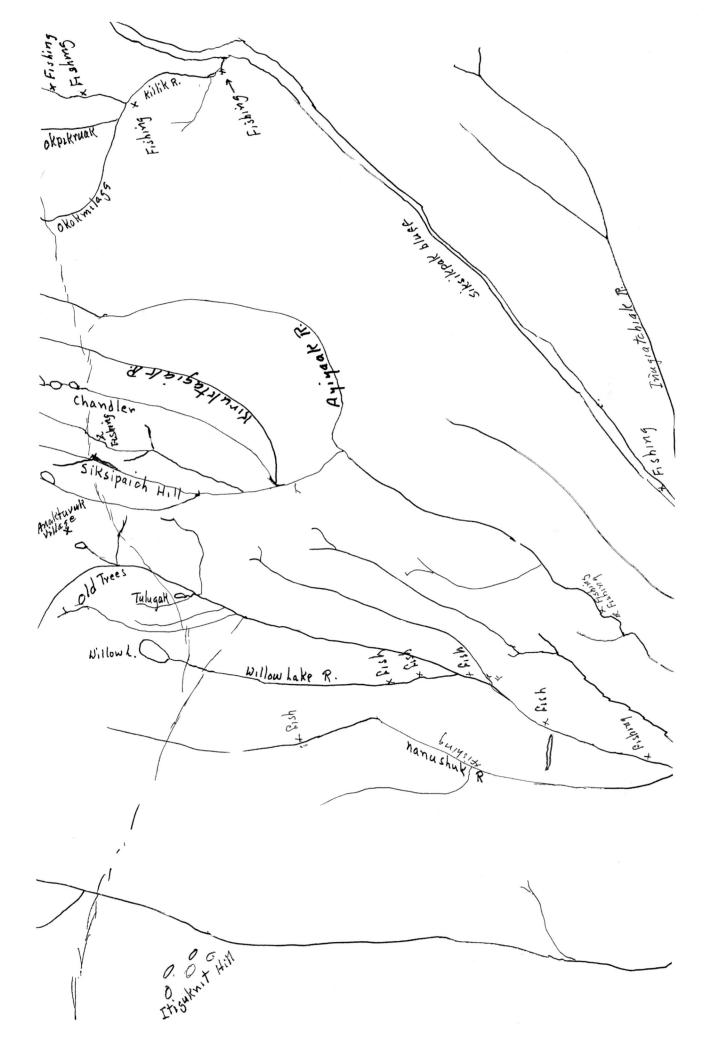

Fishing Fishing
× ×
okpikruak
× Fishing × killik R.
Fishing → Fishing
okohmilagg
Siksitpoak blake
Inigiatchiak R.
Ayiqaak R.
Kinuitagiak R.
Chandler
× Fishing
Siksipaich Hill
Fishing
Analctuvuk Village
× Fishing ×
Old Trees
Tulugak
Willow L.
Fish Fish Fish
× × ×
Willow lake R.
Fish
Fish ×
× Fishing ×
Fish
× nanushuk R
Fishing
× O O O
O
Itigukmit Hill

PLATE 33
SEAL NETTING

While fighting occurred (rarely) between the Nunamiut and their coastal neighbors, the tribes were basically identical in race, language, and social structure. Peaceful trading, even intermarriage, was far more common than battle. Still, the maritime economic base of the Tareumiut was profoundly different from that of the Nunamiut, whose survival depended most critically on one land mammal, the wild reindeer.

Whales, seals, and walruses permitted the Tareumiut to establish permanent towns of three hundred people or more, as compared with the little Nunamiut encampments of three or four dozen men, women, and children. The bounty of the sea addition-

ally made possible Tareumiut religious and political embellishments not present among the Nunamiut. No wonder, then, that when they could, which was seldom, the inlanders tried their hand at saltwater hunting. Like the rest of Nunamiut ocean lore, this method of killing seals under the sea ice was borrowed directly from the Tareumiut.

27

Seal breathing hole in winter

Seal was caught in seal net
im under the ice & young Oogrook bearded seal are caught

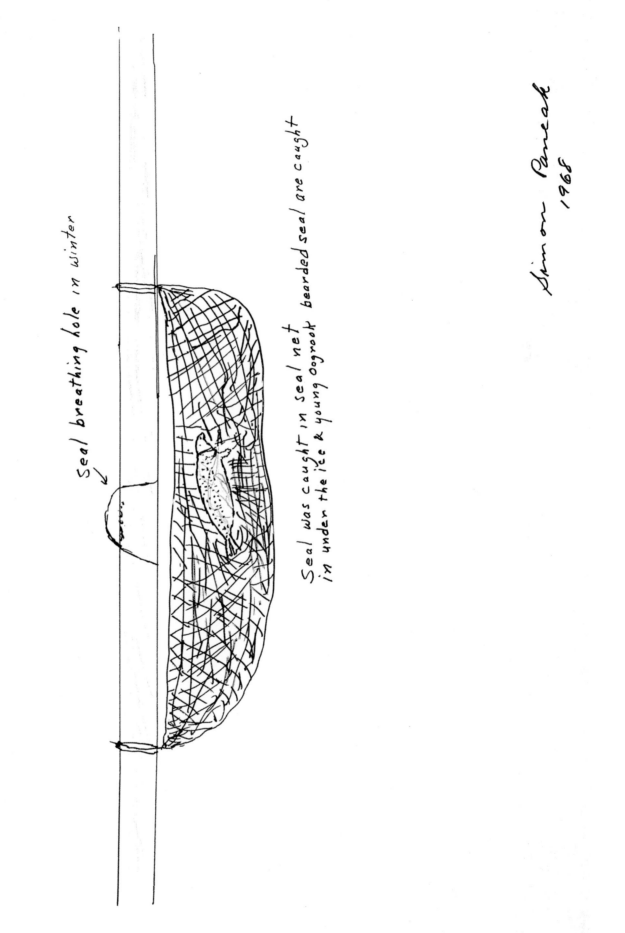

Simon Paneak
1968

PLATE 34
SNARING GROUND SQUIRRELS

Sikrik, the arctic ground squirrel (*Citellus undulatus*), is mimically named for its alarm call; walk among the *sikrik* and you will agree that the Eskimo term has it down pat. Since the early 1900s, or earlier, this small animal (a big one weighs two and a half pounds) has been known in English as the "parka squirrel," for the reason that their spotted skins make decorative (but not very warm) parkas.

Small as it is, however, its importance to northern interior Eskimos and Indians as a food animal far outweighed its sartorial value. Among the Nunamiut, it was second only to wild reindeer as a mammalian subsistence resource.

Its often very large colonies occupy dry ground in which they hibernate during the cold season. In late summer, when the ground squirrels were putting on their winter fat, Nunamiut women and men caught them by the hundreds in sinew snares set at the entrances of their burrows.

Simon Paneak
1967

A snares is made out of sinew–braided

Willow pole–Length 5 to 6 ft.

Willow Locken of Snare

No problem to catching ground Squirrels
by willow springspoles. Snare them easiley even in the ⊗ Trail)

PLATE 35
A CARIBOU SURROUND

Tutu, the wild New World reindeer (*Rangifer tarandus*), known as caribou, was the staff of life, and without this single food source the tribe's territory could not have been settled by the Nunamiut or by any other aboriginal people. Communal hunting, in which men, women, and children participated in the killing of dozens of deer at a time, was the key to Nunamiut survival, and the most common such endeavor was that of the surround, or pound (*kangigak*).

This is an ancient hunting method that in the Old World was probably in use tens of thousands of years ago. Here, after women and children have herded the deer between long, rock-cairn wings, the animals are driven across a frozen river, up over a rise, and into the pound's heart. This is a circular enclosure bordered with willow and skin nooses, which, flimsy as they are, allow time for the hidden hunters to kill the animals with arrows and lances at point-blank range.

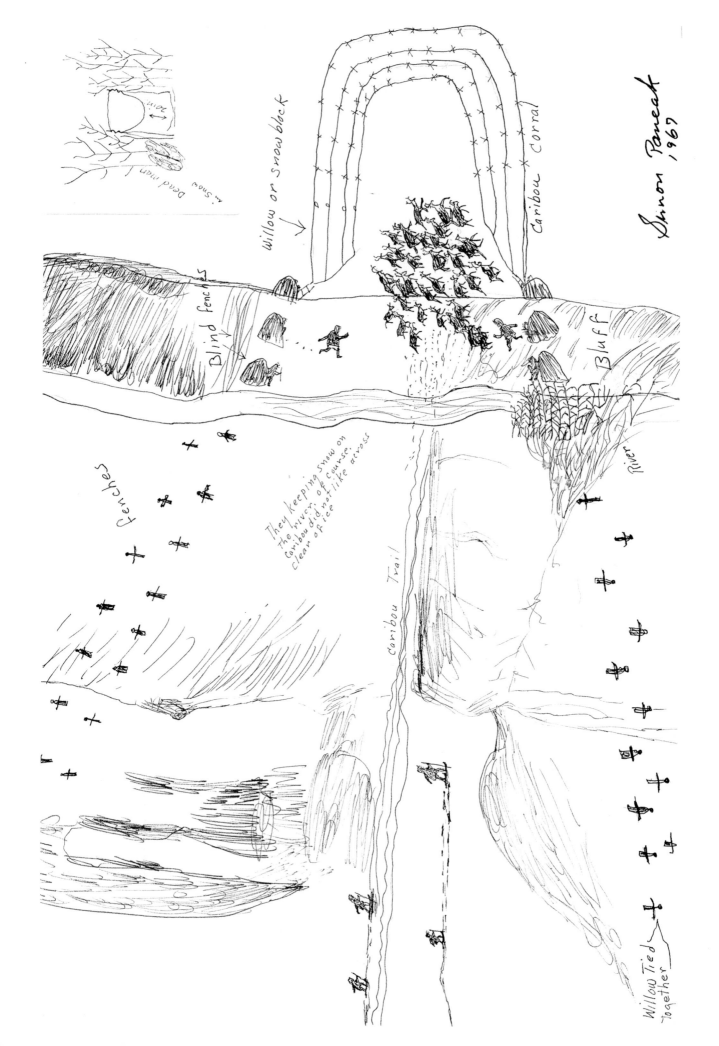

Willow or snow block

Caribou Corral

Simon Paneak 1967

Blind fences

Bluff

Fences

River

They keeping snow on
the river. of course.
Caribou did not like across
clean of ice.

Caribou Trail

Willow Tied
together

In snow

Dead man

20 in.

PLATE 36
A WATER DRIVE

Closely related to the overland surround was the water drive (*tuttusuvaqtuat*), which again involved the participation of most members of a band. Wild reindeer are accomplished swimmers. In their travels they much prefer swimming across a lake to walking around it. So given the right set of circumstances, it took little urging to get the deer to swim a predetermined course.

The noncombatant band members did the persuading, slowly and most carefully encouraging the herd down to a particular stretch of lakeshore under whose low banks lay the hunters in their *kayaks*.

Once the deer, dozens or hundreds of them, were afloat and swimming, the hunters drove in among them, killing first those within farthest reach of their lances and then those closest to the skin boats. Afterward, after the last of the herd had escaped up the far bank, the *kayak* men turned back across the lake to tow the dead game ashore.

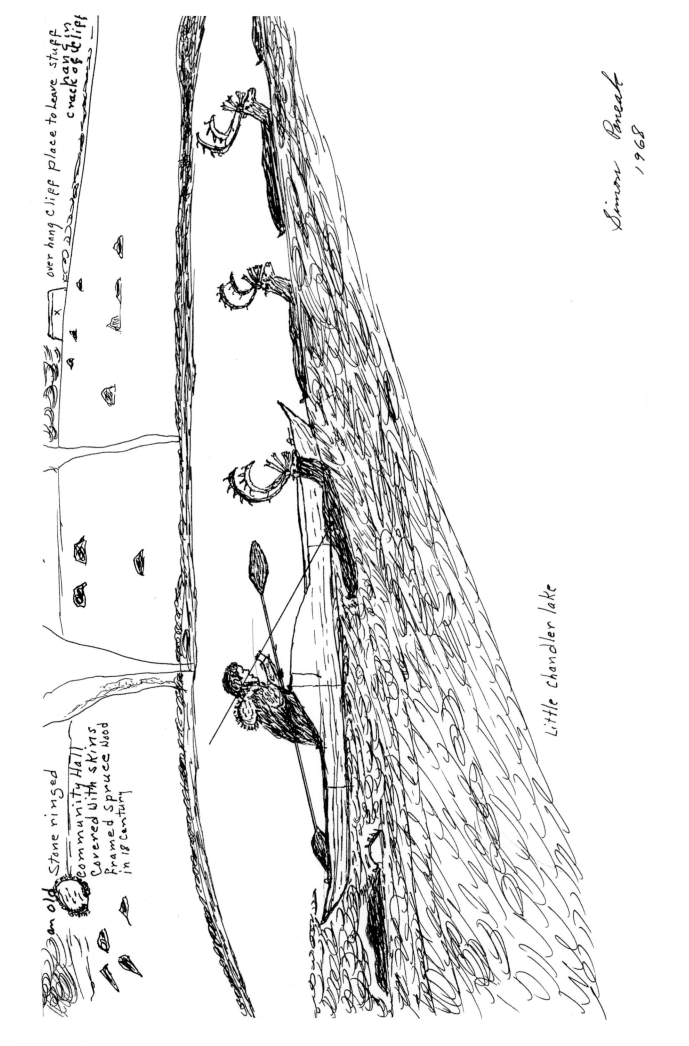

over hang cliff place to leave stuff
crack of cliff

an old
stone ringed
Community Hall
covered with skins
Framed spruce wood
in 18 century

Little chandler lake

Simon Paneak
1968

PLATE 37
BOW AND ARROWS

This drawing depicts the Nunamiut bow and a complete inventory of its arrows. The recurved, compound bow was typical of Eskimo tribes from northeastern Siberia eastward to Greenland. Quite different from American Indian bows, it was a hallmark of Eskimo material culture, its most distinguishing characteristic being its reinforcing sinews and inset pieces of antler, which made it an exceptionally resilient and powerful weapon.

Made most often of birch, but sometimes of spruce, the bow was four feet long. Arrows were of spruce, averaged twenty-six to twenty-eight inches in length, and were fletched with the wing feathers of fledgling gyrfalcons.

Arrowheads were designed for more or less specific purposes, and, as in the case of the bow, these four types were pan-Eskimo in distribution. Heads of the lower three arrows are of wild reindeer antler (when Paneak writes "horn" here he means antler), and as one would guess from his annotation, the arrowhead second from top is the most common type found in Nunamiut archaeological sites.

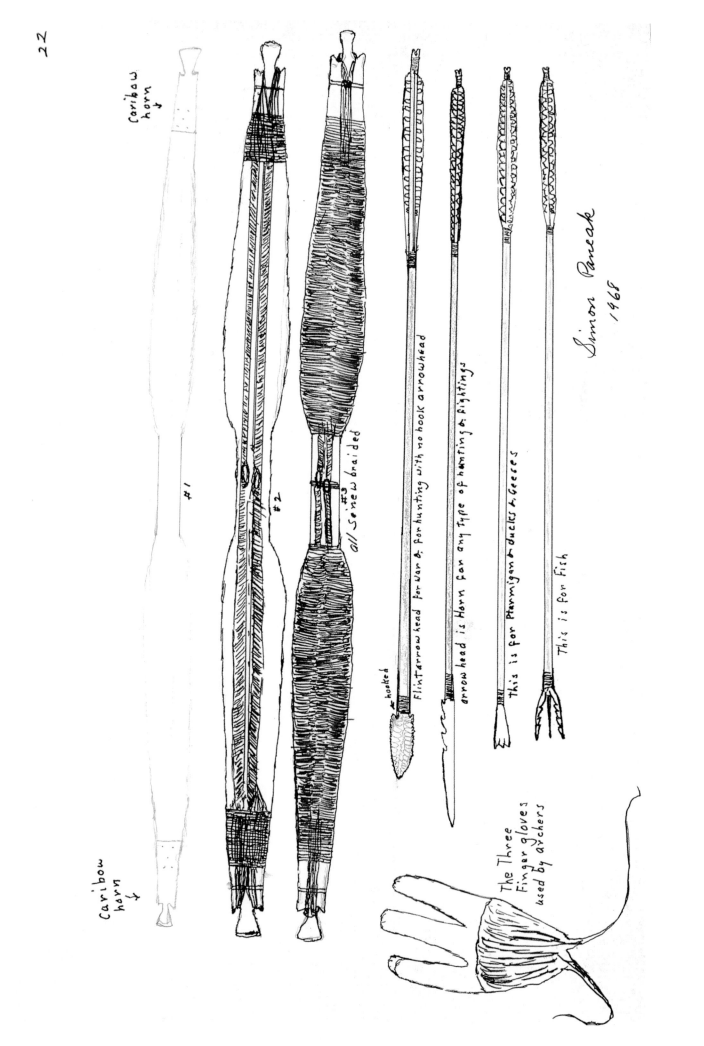

22

Caribou horn ↓

Caribou horn ↓

#1

#2

All Senew braided #3

← hooked

Flint arrow head for war & for hunting with no hook arrowhead

arrow head is Horn for any type of hunting & fightings

This is for Ptarmigan or ducks & Geeses

This is for Fish

Simon Pancake
1968

The Three Finger gloves used by archers

PLATE 38
FLINTWORKING

Most Brooks Range bedrock is
sedimentary. Over the past ten
thousand years or more, mem-
bers of a succession of tribes
(including the Nunamiut) have
quarried particular, widely scat-
tered limestone outcrops for the
raw materials of flint toolmak-
ing. Much of this flint is of a
type known as chalcedony,
extraordinarily fine and easily
worked.

Working from maps, Paneak
marked for me the locations of
several such quarries in
Nunamiut territory. The quar-
ries themselves have yet to be
visited by modern inquirers, but
their existence is confirmed by
ancient regional dwelling sites
containing many dozens of chal-
cedony artifacts.

Interestingly, Nunamiut
archaeological collections con-
tain few flint tools, more than
95 percent of their native arti-
facts being of bone, antler, ivory,
or wood. Still, the Nunamiut
knew very well the art of flint-
working, and as late as the mid-
dle 1950s, as witnessed by this
writer, an old Nunamiut hunter
carried still the ivory flint knap-
per he had used in his youth.

11

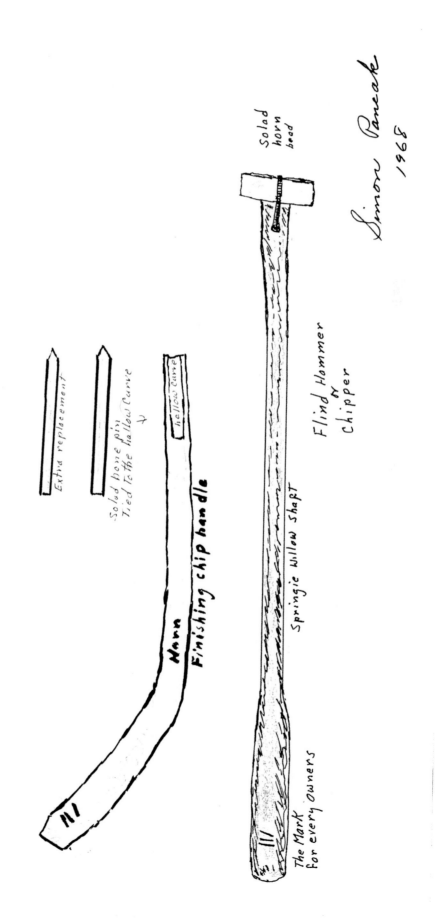

Extra replacement

Solod bone pin
Tied to the hallow Curve

hallow Curve

Horn
Finishing chip handle

Solod horn head

Flind Hammer
or
Chipper

Springie Willow Shaft

The Mark
For every owners

Simon Pancake
1968

PLATE 39
KITCHEN POTS

Nunamiut spruce-wood pots were works of art. In 1956 we found a broken example lying on the shore of Chandler Lake, where it had survived for decades in the conserving arctic climate. Made of two thin slabs cut from a green tree, the side piece of a typical pot was bent into a cylinder and its two ends then fastened with the waterproof stitching noted by Paneak. (Baleen is the fringed, plastic material hanging in the mouths of so-called baleen whales.)

This upper part was fitted into a circular groove in the bottom piece, with a precision resulting again in a waterproof seal. Meat was boiled by drop ping red-hot stones into the water-filled vessel. Because such pots could not be made from dry, Arctic coast driftwood, their green spruce pieces, or the pots themselves, were common articles of trade to the Tareumiut.

17

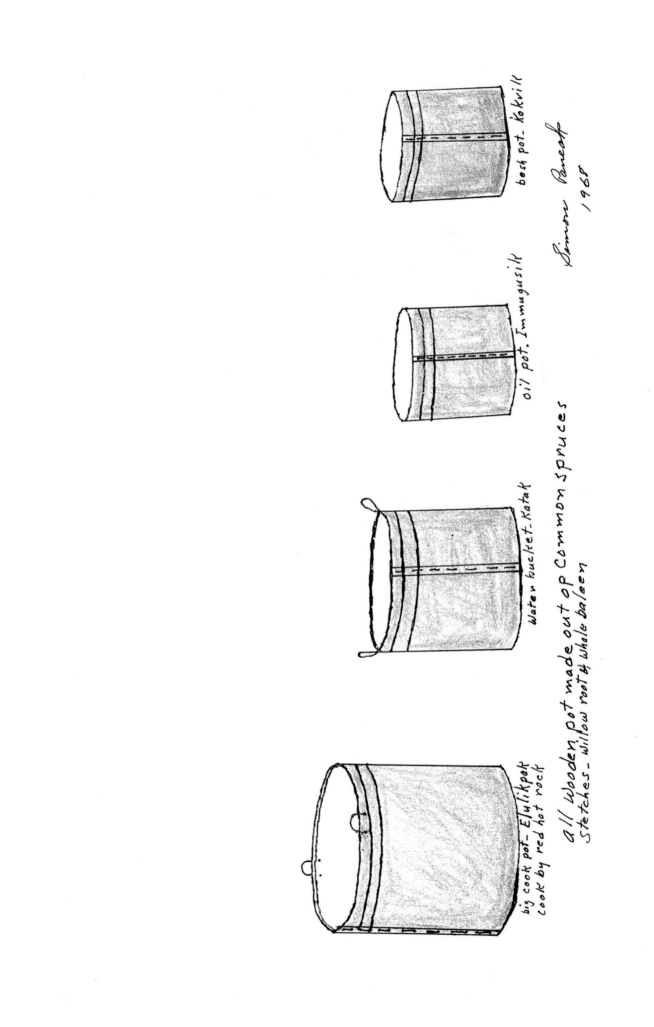

big cook pot- Elulikpolt
cook by red hot rock

Water bucket-Katak

oil pot. Immugusilk

beach pot- Kokvilk

All wooden pot made out of common spruces
Stetches- willow root & whale baleen

Simon Paneak
1968

PLATE 40
HOUSEHOLD UTENSILS

To north Alaska archaeologists, the most interesting artifacts shown here are the stone seal-oil lamp and the clay pot. As noted, among the Nunamiut seal oil was a commodity so relative-ly scarce that it was most often eaten rather than burned as fuel, and oil lamps were scarce accordingly. The example shown here is of the common coastal type that was traded to the Tareumiut from Canadian Eski-mos who had access to the best stone raw materials. Such lamps are typically large and heavy (the four drawings in this plate are not to scale), often weighing thirty pounds or more, another reason why the Nunamiut, having willows for fuel, seldom used them.

North Alaska pottery was equally uncommon. Apparently the Nunamiut made their own, but potsherds comprise far less than 1 percent of Nunamiut archaeological inventories, prob-ably because of the excellence of their light, spruce-wood pots. In my experience, the thick-walled sherds are tempered with grass.

This is the round Pan

Common spruce root: Pan - Pugutak

Simion Pancark
1968

Eskimo oil lamps
made out o R Sandstone e)
Soapstone

Clay pot - Pattigak
Story are told
how to made clay pot
mix in dough & stir together
Clay-Planniggn fethers-animal blood
Sebl oil & shaped by hand & after op all
dried up by open fire side & after dried up &
ready to cook in over fire

PLATE 41
TOOLS

We have described the coinciden-
tal but remarkably close simi-
larities between traditional Eski-
mo social structure and that of
western Europeans, and, again
coincidentally, the Eskimos seem
to have shared with modern
Americans a love of tools and
gadgets. This was true especially
of Eskimo sea mammal hunters,
such as the Tareumiut, who pos-
sessed an astonishing array of
artifacts, but the old-time
Nunamiut inventory was
impressive, too.

Although in some cases their
functions were nearly identical,
every artifact had its particular
use. These drawings show only a
few of the many Nunamiut small
tools, and with Paneak's annota-
tions they need little additional

explanation. "Mountain horn,"
though, denotes the true horn of
the wild, white sheep, while
Paneak's other "horn" notations
refer to antler. "Ligrice roots
pick" refers to the antler imple-
ment used in digging sweet
vetch roots
from frozen
ground.

*The north Alaska ice cellar (sigluaq) probably has been in
use on both the Arctic coast and in the Brooks Range for
more than a thousand years. This example, dug by the
Nunamiut in the early 1950s, is fourteen feet deep and capa-
ble of preserving meat summer and winter. Its entrance is
covered with a spruce-wood lid, and its frost chamber is
reached by a spruce-pole ladder. Photograph by Thomas H.
Follingstad, 1959.*

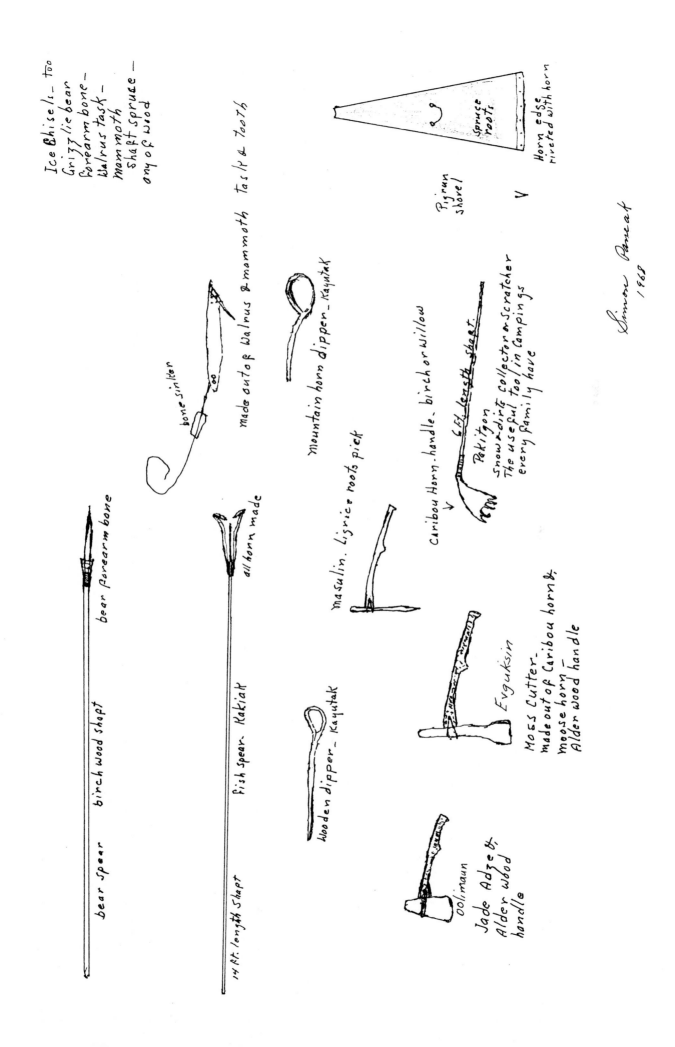

Ice Chisels — too
Grizzlie bear
forearm bone —
Walrus task —
mammoth
shaft spruce —
any of wood

Pijran
shovel

Horn edge
riveted with horn

spruce
roots

bear spear birch wood shaft bear forearm bone

bone sinker

Made out of Walrus & mammoth task & tooth

Mountain horn dipper — Kayutak

masalin. Licrice roots pick

Caribou Horn.handle. birch or willow

6 ft. length shaft.

Pakitgon
Snow & dirt collector or scratcher
The useful tool in campings
every family have

14 ft. length shaft Fish Spear. Kakiak all horn made

Wooden dipper — Kayutak

Evguksin

Moss Cutter —
made out of Caribou horn &
moose horn
Alder wood handle

Oolimaun
Jade Adze &
Alder wood
handle

Simon Paneak
1965

PLATE 42
UNDERGROUND FOOD CACHE

Preserving game, fish, and all but the most inedible of artifacts from animal thievery and destruction was an unending chore; the list of marauders begins with blowflies and ends with sled dogs and bears. In occupied camps, dogs were the worst of the offending vertebrates, which was a principal reason for the unwritten rule, observed commonly in the breach, that all but small pups be kept tethered.

Largely for the same reason, each Nunamiut house had its nearby cache, six or seven feet tall, made of willow trunks and poles. In addition to this type of facility, there were subsurface winter caches wherein frozen meat, fish, and other food could be left unattended while the people were off in other parts of the territory. As Paneak explains, this underground example is designed to keep out even wolverines, which, except for human miscreants, are the worst of north-country thieves.

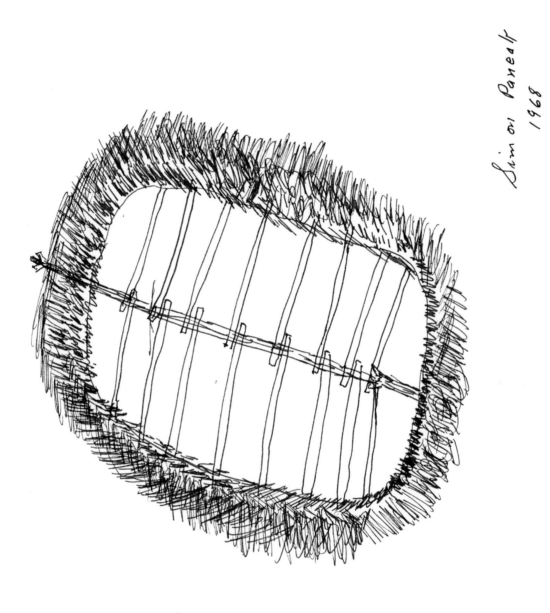

Simon Paneak
1968

The ground dig before
freeze up the ground
put frame willows a
covered by wet sod
leave open end
and after freeze the
ground filled up
some fish-meat
poke of mashoo-oil etc.
and shud by rock & dirt
water on to make stick
Together rock & dirt
no wolverine can dug

PLATE 43
LANCING A GRIZZLY BEAR

In addition to its casual value as a food source, *achlach*, the grizzly bear (*Ursus horribilis*), provided the Nunamiut with the raw materials for various artifacts. Most important was its heavy hide, which when cured with hair intact served as a luxuriant mattress (as this writer can attest) or as a hanging door in skin or moss houses. This north Alaska and northwesternmost Canada bear, known commonly as the tundra grizzly, is every bit as dangerous as its more southern counterparts, and to kill one with native weaponry required both skill and extraordinary nerve.

A big adult weighs nearly six hundred pounds, its front claws are nearly four inches long, and it can kill a bull caribou with a single blow to the head. Thus, slaying a tundra grizzly with a lance was an act of valor that assured the hunter a place forever secure in Nunamiut oral history.

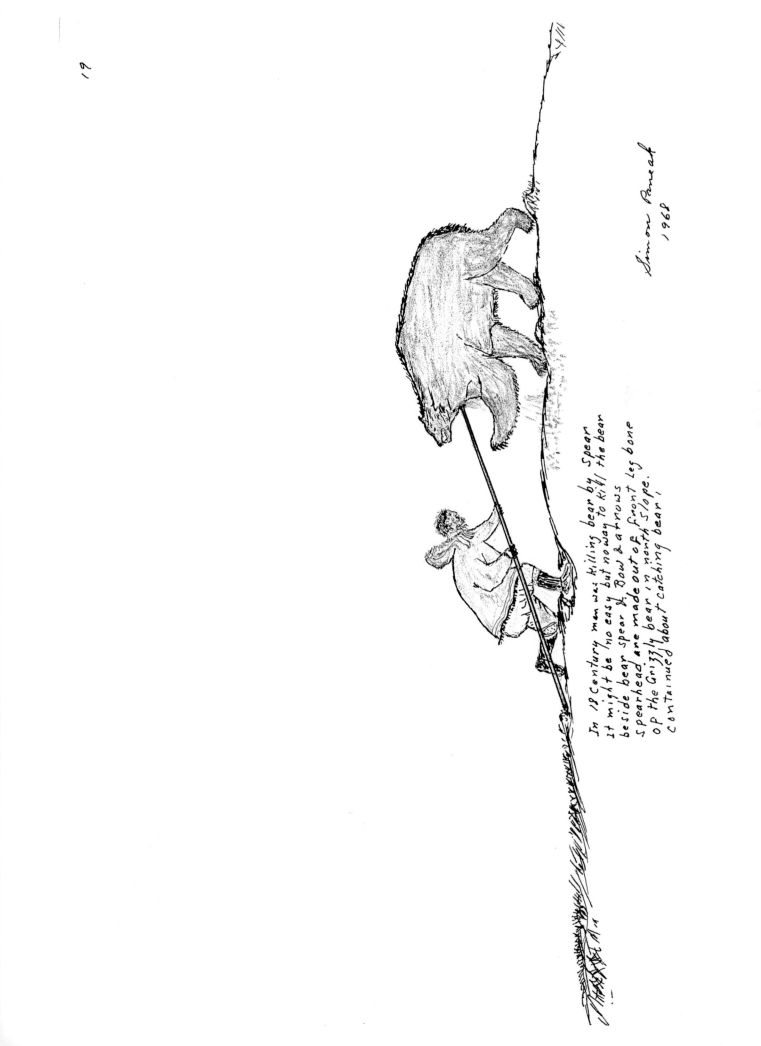

In 18 century men was killing bear by spear it might be no easy but no way to kill the bear beside bear spear & Bow & arrows spearhead are made out of front leg bone of the Grizzly bear in north slope. Continued about catching bear.

Simon Paneak
1968

PLATE 44
A SNARE IN THE WOODS

Snares of several varieties were artifacts of major importance for both the Nunamiut and their forest-dwelling Indian neighbors. Certain snares offer the advantage of allowing the hunter to go off on other business while the unattended devices do their work. Additionally, they permit the killing of animals, such as the lynx, that are so reclusive that they can hardly be taken with other native weapons. And snares can be used in essential conjunction with, for example, bows and arrows.

By about 1920, the introduction of firearms and steel traps had prompted the Nunamiut to abandon much of their snaring technology. But during the Second World War, when they were unable to trade for rifle ammunition, they fell back on their old techniques and methods, using snares to kill white sheep, bears, and even moose. This snare, down among the northernmost trees, has been set for a grizzly bear.

This bear, killed with a rifle rather than with lance or noose, shows nevertheless something of grizzly awesomeness. Shot near Anaktuvuk Pass, it weighed four hundred and eighty pounds. Photograph by Robert L. Rausch, 1950.

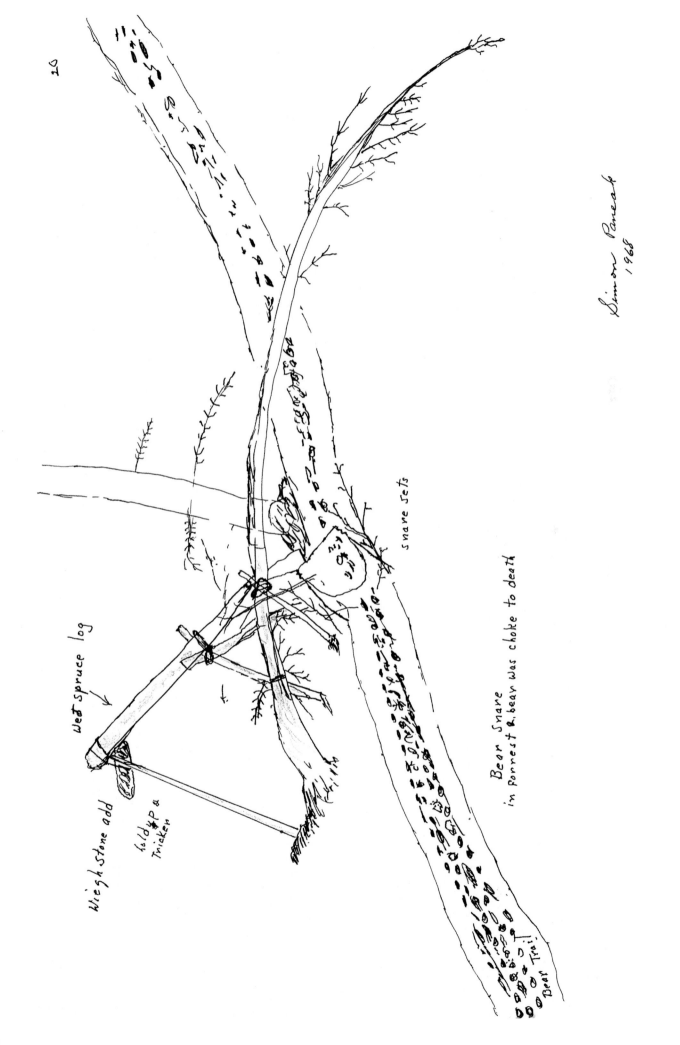

20

Wed spruce log

hold up &
Trigger

Wiegh stone add

snare Sets

Bear Snare
in Forrest R. bean was choke to death

Bear Trail

Simon Paneak
1968

PLATE 45
CAUGHT

Enhancing the tundra bear's awesome reputation are the oft-told tales of its occasional emergence from winter hibernation to bathe in warm spring pools in the frozen rivers. And then, with air temperatures far below zero Fahrenheit, when it leaves the water its coat freezes and it goes clanking over the landscape, impervious to arrow, lance, or spear. But these stories are true, and unlike black bears, which remain holed up all winter, the North Alaska grizzlies do indeed leave their dens from time to time, and when they were wearing their armor, nothing would do but a noose.

Summer or winter, because of both the size of the quarry and the necessarily resilient and springy components of the noose, it was required that grizzly snares be set in the woods, where spruces were available for their construction. The noose itself, baited with meat, was of heavy, braided rawhide, and probably far more grizzlies were killed this way than by the heroics shown in plate 43.

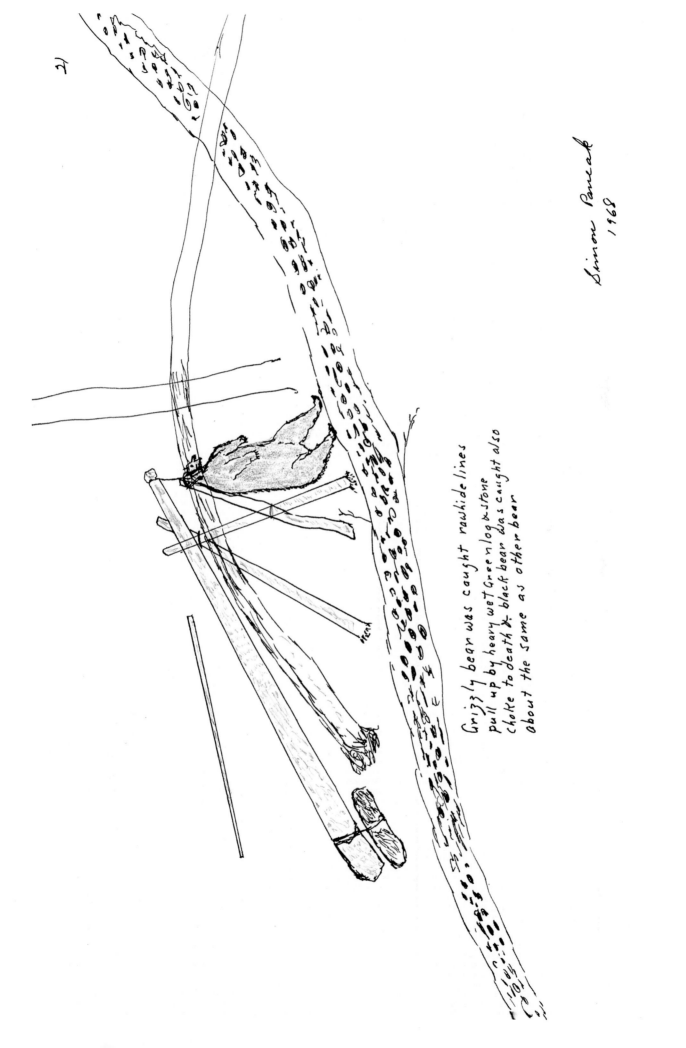

Grizzly bear was caught rawhide lines
pull up by heavy wet Green log & stone
choke to death & black bear was caught also
about the same as other bear

Simon Paneak
1968

2)

PLATE 46
A WOLVERINE DEADFALL

To protect your face in blizzards and bitterly cold weather, the fur ruff of the outer parka hood is pulled forward, fur inside, so that you view the world through a short tunnel while your breath condenses and freezes on the hairs of the ruff. Getting rid of this ice is a continuous chore, and skins of most furbearers require that you squeeze or scrape it off with your bare fingers.

But skins of wolf or wolverine are of a different nature, and with ruffs of their furs, the ice falls away with a slap or two of your mittened hand. Accordingly, winter parka hoods were furnished with skins of these animals, and ruffs of *kavik*, the wolverine (*Gulo luscus*), were considered the superior of the two. Because wolverines are scarce on the Arctic coast, their skins were among the most important of Nunamiut resources traded to coastal Eskimos.

Now begining of sets
begining from bottom first

Shape
like a
Box &
ready to
lay Top
rober

all finished & put willows
all round except door but
plug with dry moss so snow wont fill inside
in stormy weather.

Smear animal
fat or sea animal oil
on the door holder
in both so animal
can find entries easily.

Post

← Smear with fat

Simon Paneak · 1968

PLATES 47–48
SNARING A RED FOX

Nunamiut fox trapping was mainly a product of the fur trade. Until well into the 1930s, winter skins of both *kayuktuk*, the inland dwelling red fox (*Vulpes fulva*), and *tereganiak*, the coastal arctic fox (*Alopex lagopus*), were principal sources of income—"income" meaning primarily their value in barter for white man's guns, ammunition, pots and pans, and other desirables.

Arctic foxes were beyond practical, ordinary reach of the Nunamiut, but *kayuktuk*, including its rare mutant, the silver fox, ranges everywhere in Nunamiut territory, and its skins were the single most important resource that introduced the

Nunamiut to the "advantages" of civilization.

But leaving out the fur trade, the best of red fox skins provided the native people with dressy parka ruffs. They were not practical in winter, but in summer they kept away mosquitoes, and they were, and are, beautiful.

Forked willow pole hold up the
snare which tight up to Rock and
fox a saw the meat & catch it in
the snare & got the meat back
out of the little house & pull
shaken the rock & fall off
the rock from Top & pull
fox up to fork of the Tip willow
in above & shaken rock & fill
off & pull fox up to forked &
choked to death

Rock

snow block &
stick together make little house

Simon Paneak
1968

2

other Fox
are looken
the Red Fox
what happining

caribou
meat Cache

Heavy stone is fall off Fox &
from Top shaken by Fox &
pull Fox up to choke to death
in Forked willow Tip
The stone could be heavier
Than Fox

Lake

Simon Paneak
1968

CATCHING A MARMOT

Sikrikpuk, the arctic marmot (*Marmota broweri*), belongs to the same genus and is about the same size (a big one weighs twelve pounds) as the familiar eastern U.S. woodchuck. It lives in the mountains, and high among the rocks in the early spring, with the low arctic sun through its hoary coat, it is as elegant an animal as you would ever want to see. Standing at the entrance to its den, surrounded still by snow, it has an uncanny resemblance to a miniature silver-tip grizzly.

Generations of Nunamiut have killed arctic marmots for food and furs, but as with red foxes, more intensive trapping seems to have come with the fur trade. Paneak tells, for example, that as a young man, he once traded the skins of thirty *sikrikpuk* for white man's grub and ammunition. (As the reader will note, his explication of the first of these two drawings is somewhat more opaque than are his usual straightforward annotations. Nevertheless, one gets the picture.)

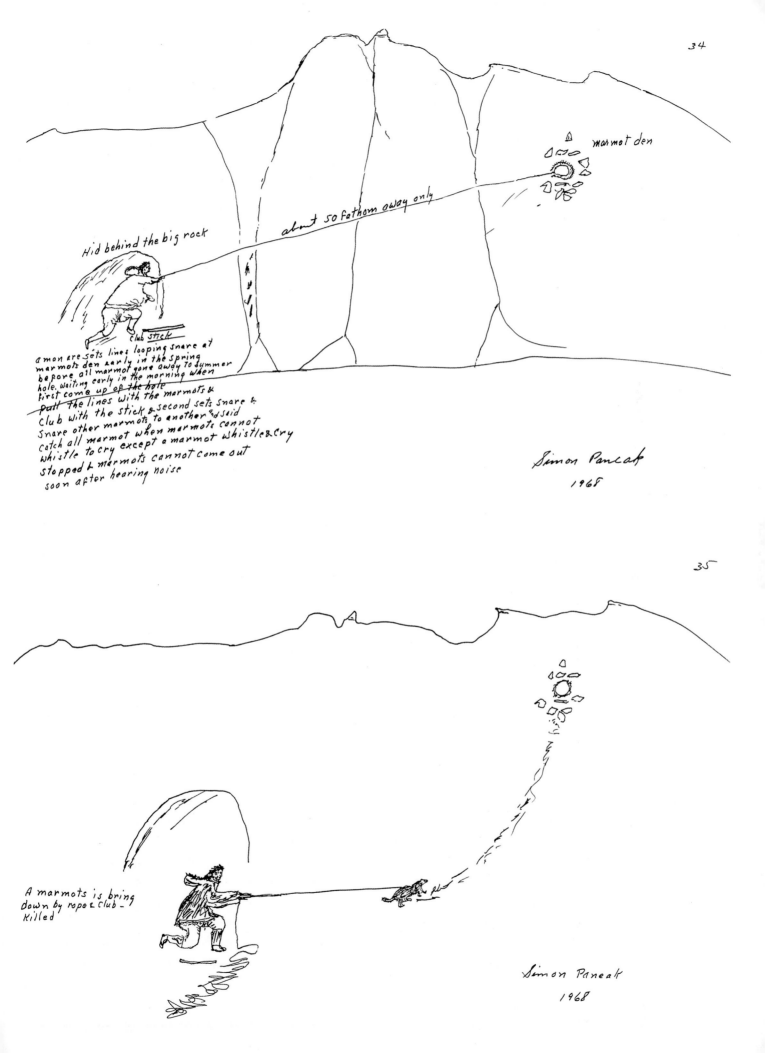

marmot den

about 50 fathom away only

Hid behind the big rock

club stick

a mon are sets lines looping snare at
marmots den early in the spring
before all marmot gone away to summer
hole. waiting early in the morning when
first come up of the hole
pull the lines with the marmots &
club with the stick & second sets snare &
snare other marmots to another 3d said
catch all marmot when marmots cannot
whistle to cry except a marmot whistle & cry
stopped & marmots cannot come out
soon after hearing noise

Simon Paneak
1968

A marmots is bring
down by rope & club -
killed

Simon Paneak
1968

PLATE 51
ON THE ICE OF THE COLVILLE

Travel was mainly a matter of slogging over rough terrain. From the air, the Nunamiut tundra looks as smooth as a fairway, but on the ground it consists typically of close-growing sedge tussocks, several inches tall, that to us modern wilderness lovers provide for abominable walking. In winter, because of the scanty snowfall, going across country by dogsled is just as bad.

Both in summer and winter, rivers permitted easier travel, but only under particular circumstances because all sizable tribal territory streams run either north or south while most of the Nunamiut annual round took them either east or west or among little headwaters creeks.

Nevertheless, whenever practical, the rivers were used. In this picture two families are heading home over the winter ice of the Colville. As shown here in detail, because of an unusually heavy snowfall, it was tough sledding still, but tough sledding came with the territory, in a manner of speaking.

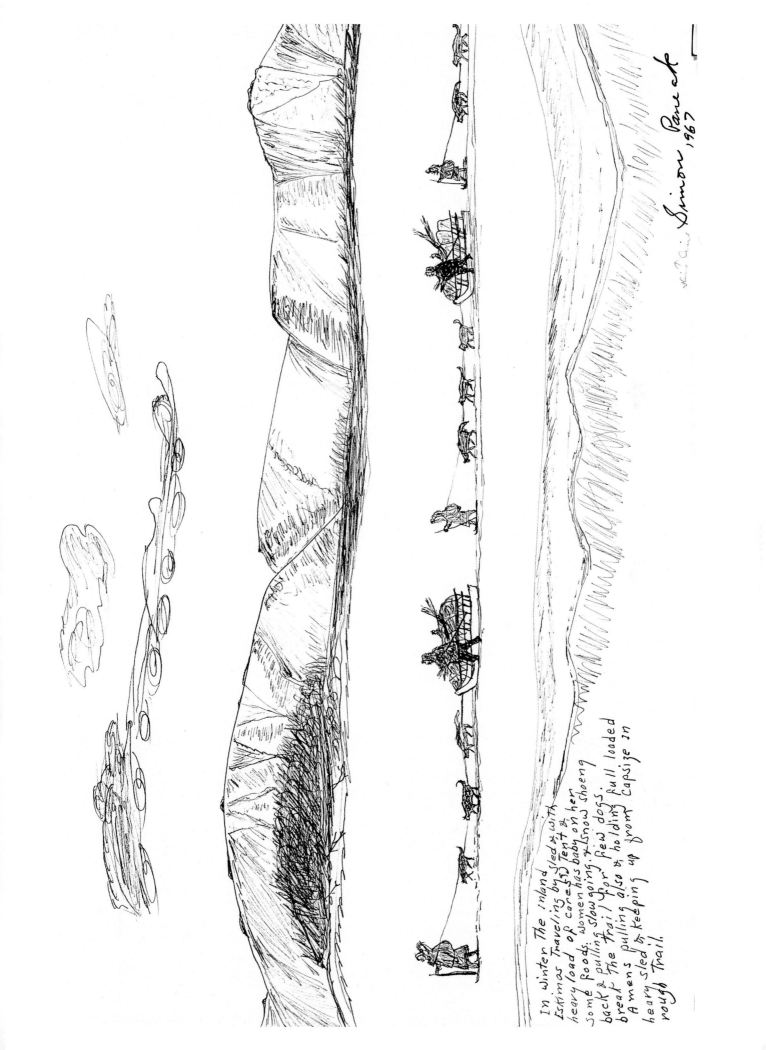

In winter the inland
Eskimos traveling by sled & with
heavy load of cariboo, tent &
some foods, women has baby on her
back & pulling slow going. + snow shoeing
The trail for few dogs. full loaded
breat pulling also & holding full loaded
A men's pulling also & holding
heavy sled & keeping up from rough trail.
rough trail.

Simon Panieak
1967

DOGSLED

As described elsewhere in these drawings, Nunamiut travel was accomplished primarily by overland walking rather than by boating or sledding. Under the right conditions, however, the dogsled (qamun) was the only means whereby a man or a family could traverse long distances over relatively very short spans of time. Especially when their surfaces were blown clear of snow, the larger rivers, flowing north and south from the Arctic Divide, provided the right conditions.

Of course, to take full advantage of them, your business had to be either northerly or southerly, but on good ice, a man with, say, eight dogs and a three-hundred-pound sled load could travel eighty miles in a day.

If you are handy with tools, you can build a perfectly good Nunamiut dogsled by following these careful drawings of a twelve-foot example. Note that in typical, expert Eskimo fashion, this sled is designed to be easily disassembled for transport by umiak (plate 55).

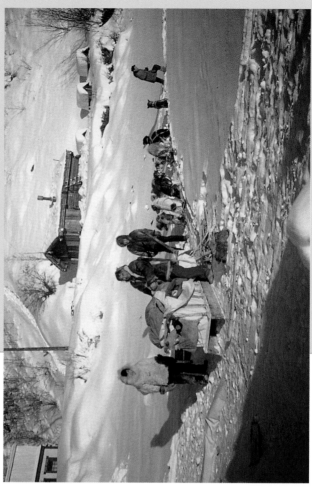

In the 1940s following their return to the Arctic Divide, Nunamiut contacts with the outside world were few and far between. Infrequent, arduous overland trips to Crouder's trading post at Bettles on the Koyukuk River provided them with rifle ammunition and other white man's goods traded in exchange for furs. This particular expedition involved a round-trip of nearly three hundred miles. Photograph by Verree Crouder, 1947.

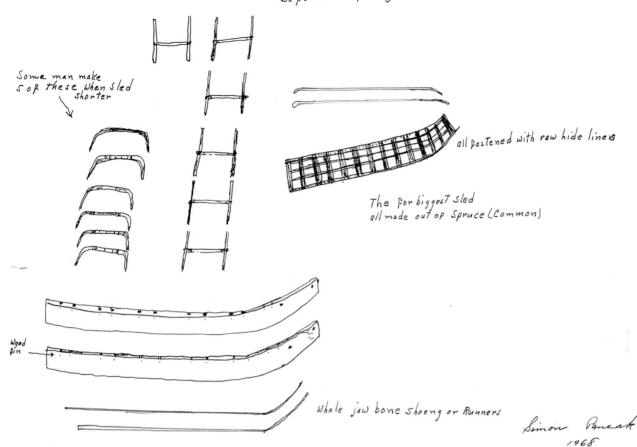

Some man make
5 of these when sled
shorter

all fastened with raw hide lines

The for biggest sled
all made out of Spruce (Common)

Wood
pin

Whale jaw bone shoeng or Runners

Simon Paneak
1968

5

all fastened tight up in all connicted part with Rawhide lines

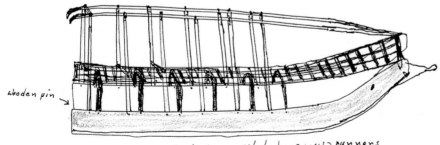

wooden pin

Ready to go. Whale bone (jaw) Runners
The big looken sled but light than our
present heavey sled & work better in soft
deep snow
Take down into pieces & bundled
when a moving to different area
in skin boat

Simon Paneak
1968

PLATE 54
SNOWSHOES

Tundra snowfall is so light and wind-scoured that sometimes neither snowshoes nor skis is needed. But in the woods south of the Arctic Divide, the snow lies deep, and one or the other is a winter necessity. Before the coming of the white man, American natives of the far north did not have skis, but for thousands of years the northernmost forest-dwelling Indians have had snowshoes, the best of which were made by the northern Athapaskans, whose tribes include the Nunamiut's nearest neighbors.

Over time, several Eskimo tribes borrowed the idea, and thus the Nunamiut came to make their own. Nunamiut snowshoes, *taglu*, are not as beautiful as those of the Athapaskans, but they are good and carefully made, so much so that on one journey when Paneak and I were traveling in the forest, it took Paneak two days to find just the right birch tree for his new pair. Men's snowshoes were typically about five feet long. Their webbing was of rawhide.

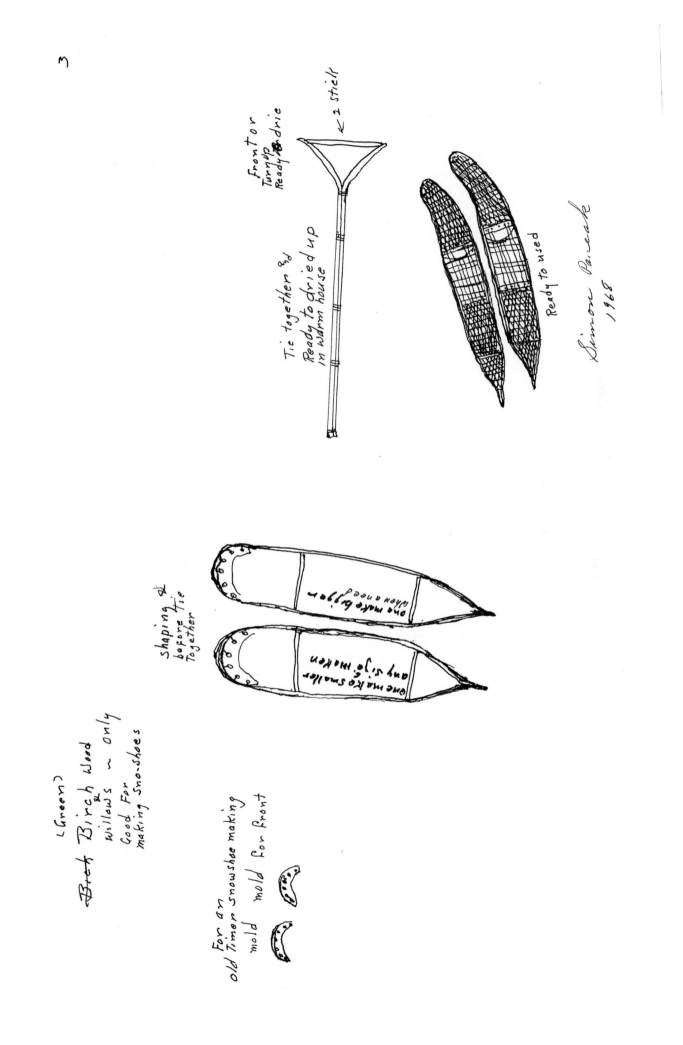

Simon Paiceak 1968

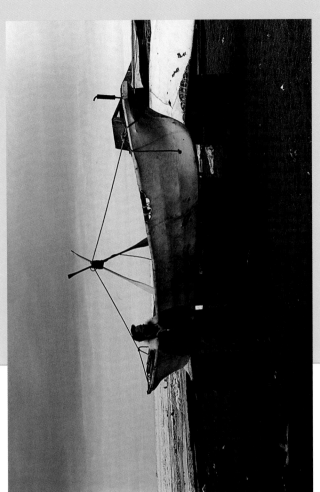

This picture, with Leo Pospisil for scale, was taken at Point Barrow, where after many centuries the light, elegantly designed umiak had remained the principal Tareumiut whaling and walrus hunting boat. Several decades before 1957 its use had been abandoned by the surviving Nunamiut, but this example is identical to those illustrated by Paneak. Photograph by the author, 1957.

PLATE 55

AN *UMIAK*

In Western literature, the Eskimo *umiak* is often called "the women's boat" because it is large enough to carry a family plus ample provisions and gear (plates 57 and 58). This writer, for example, remembers a Tareumiut *umiak* in the sea off Point Barrow with the noses of the family's numerous dogs poking out from under a mountain of cargo. In addition to this function, however, its most important use in Arctic Alaska was in whaling, an exclusively male pursuit.

In addition to showing how an *umiak* was transported by dogsled, this drawing illustrates something of its basic design. Note its outline and the distinctive narrow bow and stern. Cov-ered with seal skins, its frame pieces were cut from carefully selected driftwood. Typically thirty feet long, it had a beam of about six feet; its flat narrow bottom was two and a half to three feet wide. Despite these dimensions it was so light that, when empty, it could be carried short distances by two or three people.

Butchered Sam the meat & blubber & muktuk and cooked by boiling water.
Stored the meat & blubber & seal skin pokes for winter food.
After the meeting, he and Kotzebue and Noatak people going up on the Noatak river
to ova and Kotzebue and Noatak many families started across
after the meeting up upper Noatak river until late April
Staying him being ad no upper Noatak river probably by Howard's Pass to upper Colville R. & big group
Northern Brook range, probably by Howard's Pass to upper Colville R. & big group
in the mouth of Itkillik on Colville R. waiting for ferries across for clearing (?) of Killik
after the ice gone, floating along in Colville R. met other group Eskimos at the mouth of Killik
on Colville R. had enjoyed meeting – dancing other thick many gand. and continued travel (?) met
An other group that rilaty & friend & Sons that thing fanning of Utukeak Eskimos go along with them
they had met in the mountain near Howard Pass, same people, by how
after, different to stays like Noatak Utukeak Kangi and the upper Colville R. Killik Anaktuvuk
only different

Called themselves
Noatakmiut
Utukakmiut
Killikmiut
Kakmalikmiut _ or Anaktuvukmiut

Sam Laung uasca
Not too much different
Sound about the same

Umiak
Frame
only
when a haul
in over land

oogrook rawhide line

hold up steady

Stick

Sled

Simon Paneak
1968

PLATE 56
THE NUNAMIUT *KAYAK*

The Nunamiut *kayak* is of special interest because it seems to say something about Nunamiut tribal origins. Most Eskimo tribes—which in the aggregate were distributed from western Alaska and northeastern Siberia to east Greenland—had their own distinctive *kayaks*, small sealskin-covered boats used mainly by men and mainly for saltwater seal hunting. With some exceptions, *kayak* differences from tribe to tribe were stylistic rather than functional, but each style, nevertheless, reflected what members of a particular tribe thought was the proper way a *kayak* should look.

Various artifacts from Nunamiut archaeological sites argue for close ties with the Arctic coast of northernmost Alaska rather than with coastal or riverine areas to the east or west. Although while Nunamiut *kayaks* are reputed to have been narrower than their Arctic coast counterparts, and sometimes were covered with caribou hides rather than sealskins, the boat shown here is unquestionably of the Point Barrow Tareumiut style.

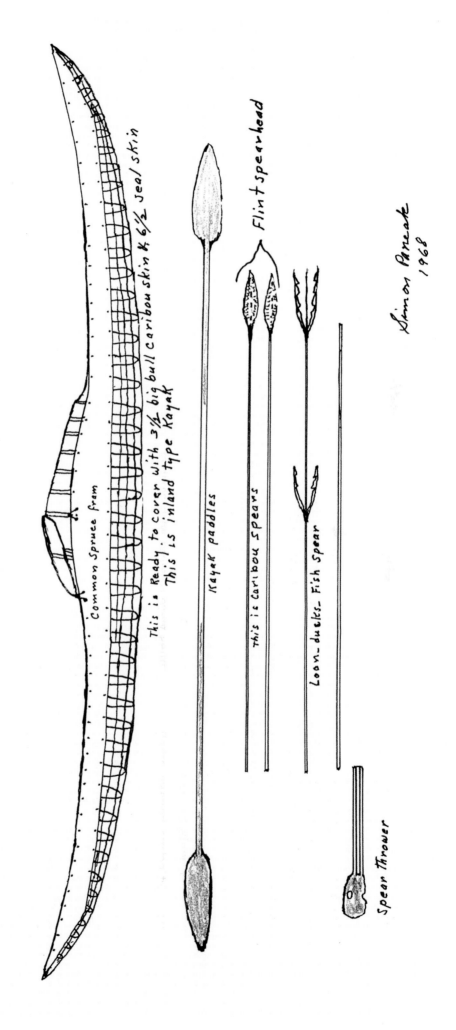

28

Common Spruce fram

This is Ready to cover with 3½ big bull Caribou skin & 6½ seal skin
This is inland type Kayak

Kayak paddles

Flint spearhead

this is Caribou spears

Loon-ducks- Fish Spear

Spear Thrower

Simon Pancak
1968

PLATE 57
A DOWNRIVER BOAT

This craft, framed in spruce and willows and covered with caribou and white sheep hides, was built in a few hours by Paneak and his friend Kakinya for a trip down the length of the John River. Their destination was the trading post at Bettles. Even though Paneak calls it an *umiak* it is not an Eskimo boat; note its square bow and stern and its wide, flat bottom. Instead, it resembles the Kutchin Athapaskan skin-covered boat designed for temporary use and for downstream travel only (McKennan 1965, 42; Osgood 1936a, 57, 58, 62), and we assume this style is of Indian origin.

The example illustrated here was twenty feet long and eight feet wide, and, as Paneak explains, lacking nails its parts were held together with willow ties. Two poles and a paddle were used in steering it down the one hundred miles to Bettles. In addition to the two men and their gear, it carried their ten pack dogs.

Elijah Kakinya & I my ready every things we (could use) & we desired to take good 10 days & with (pack)
loaded our dog (packs) in the evening, and early morning & breakfast nice & early morning soon
after we finished eating. Then we (start) that morning, its on my of the mountain fast weather soon
middle part of September. As we saw some wolfs on our way out could not (get) catch up. That was
we reaching. The mouth of Kivik Cr. to where we could built (late in evening) it was fairly chilly. The
soon our 10 days tried up (with we put) our 8x10 wall tent. So but no stove we carry (and) not a (good open fire). The
nice & warm. We have plenty dead good wood & that we could. Some heat & get a (good open fire)
dry meat, much like a ring dry of air & also people who are (living) that at way & for supper day
real our skin sleeping (to) for our have bed sleep. We heat & the we wake from our
nice sleep. Built our just on the (of tent) we carry only one little boy are (good) on such
cutting. Small common spruce poles & together we (place) we have looking. Willow
roots. To tie together conection of which frame. (Push up) we do not have any nails. No hammer
we have & we use some green willows for rib for which & then we (almost finished)
before noon except we had to do some sewing the (raw) skin to make water tight
that the skin over the frame & (stretch) & tie by willow roots. Here drawing in below the frame
how look like

Bow

Stern

Flat bottom

About length 20 ft & 8 ft width & Bow & Stern is about the frame wideness
All connection are to (left) with all willow roots is strong (after) all finished done
we put skin over & stretch all we could do it pretty tight & soon we have found
we found down to Kivik water. Seem to be the load (but) still we never enjoy
until we loaded with 10 fat dogs down (our gears) & we have got to make it
2 long poles & one paddles (and one oar) then we load & how high we ought to
frame above water lines & about couple foot about water lines, it was pretty good
cont. 0.5

PLATE 58
HEADING HOME

Nearly all Eskimo tribes owned skin-covered boats of two types: the familiar *kayak*, employed usually as a one-man seal-hunting boat, and the big, open *umiak*, used in whaling but most universally for transport. The inland Nunamiut had both of them but their *kayaks* were caribou-hunting craft, and because of the shallow, rocky nature of Nunamiut streams, their *umiat* (plural of *umiak*) were useful only on occasional visits to salt water or on the lower reaches of the largest north-flowing rivers.

Here, a Nunamiut family and its dogs are tracking an *umiak* upstream from the trading rendezvous at Niklik in the Colville River delta. Once they reach Umiat, the head of navigation on the Colville, they will cache the big boat and, with the dogs as pack animals, will walk the one hundred overland miles to their home on the Arctic Divide.

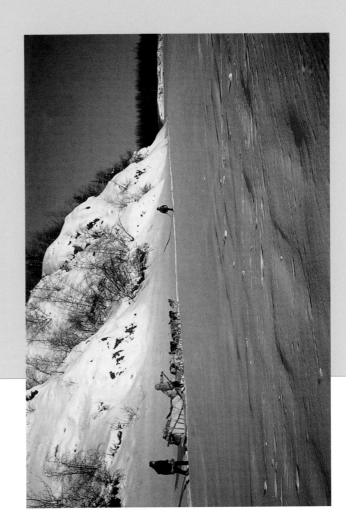

After two days of trading, men and dogs turn back northward to the Nunamiut camp at Chandler Lake. Much of the trip will be over the ice of the John River through the snowy woods of the boreal forest. On snowshoes, the Nunamiut man up ahead is breaking trail for the dogs, tramping down ten inches of fresh snow. Photograph by Verree Crouder, 1947.

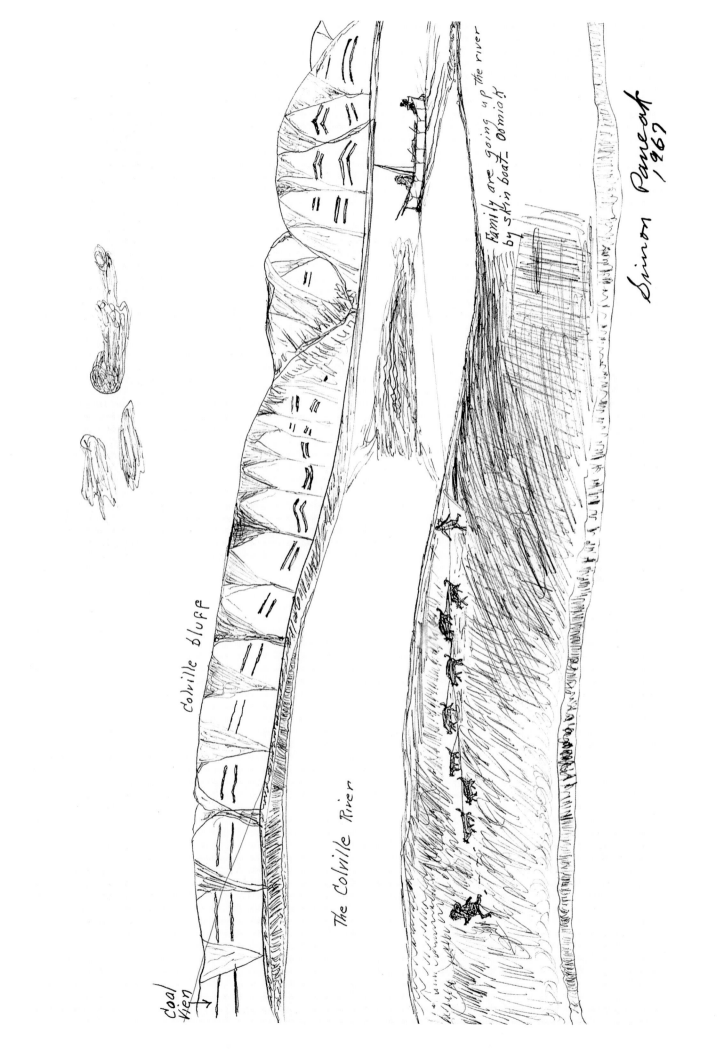

Coal
Vien

Colville Bluff

The Colville River

Family are going up the river
by skin boat -- Oomiak

Simon Paneak
1967

Covered with newly fallen summer snow, this Arctic Slope river system reminds us of the stark realism expressed in Simon Paneak's cartography. While they saw their country only from the ground, the Nunamiut knew intimately its details. Photograph by the author, 1957.

NUNAMIUT CARTOGRAPHY

We have remarked on the importance of what may be termed *mental* maps in traditional Nunamiut life. When, in the late 1940s, the U.S. Geological Survey first began aerial mapping of much of north Alaska, their ground parties relied on native advisers to provide names for rivers, lakes, and other terrain features.

Within traditional Nunamiut territory, such landmarks, among others, as Chandler Lake and Anaktuvuk and the Colville and Anaktuvuk rivers had appeared on late-nineteenth- and early-twentieth-century maps, but 90-odd percent of all streams and lakes, for example, remained unreported and unnamed until the arrival of the aerial photogra-

phers and their inquiring colleagues. As it turned out, the Nunamiut knew their countryside so well that they offered many more topographical names than the government people wanted or needed. Numerous names in these three drawings do not appear on even the latest, large-scale maps of north Alaska.

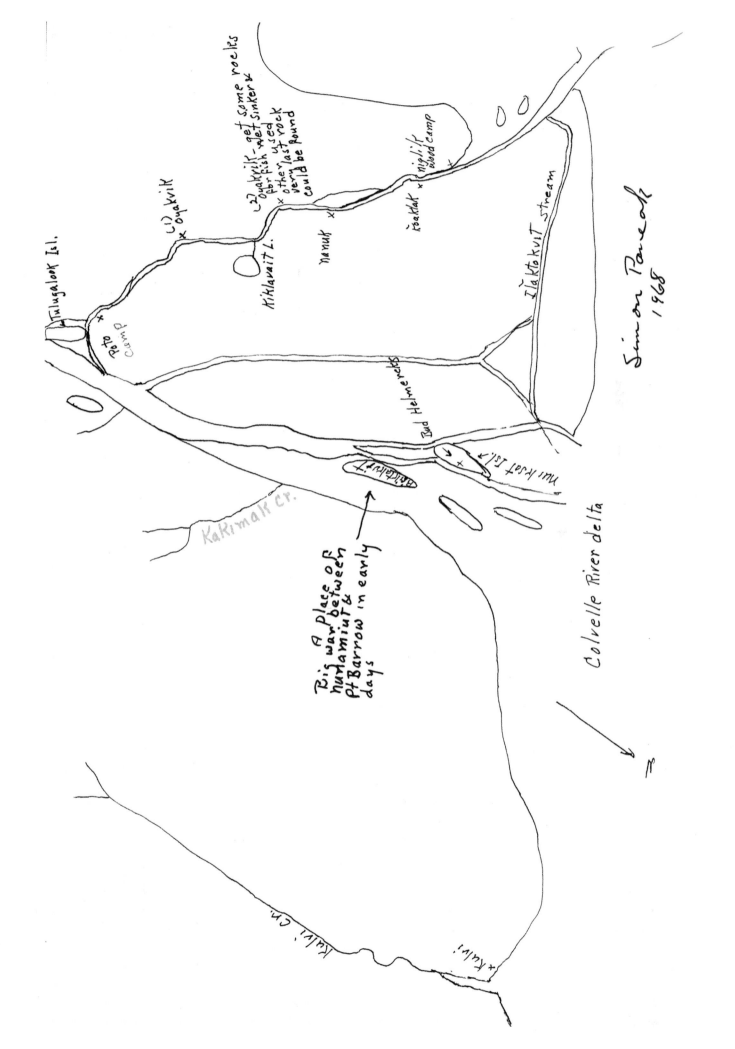

Tulugalook Isl.

Peto Camp

Oyakvik

Kiklavait L.

Oyakvik – get some rocks for fish used other last rock very could be found

nanuk

Isaktak niglik wood camp

Ilaktokvit stream

Bad Helmerits

Kakimak Cr.

Nuiksat Isl.

Ahilahuit

A place of war between numamiut & Pt Barrow in early days

Colvelle River delta

Kulvi Cr.

Kulvi

Simon Paneok
1968

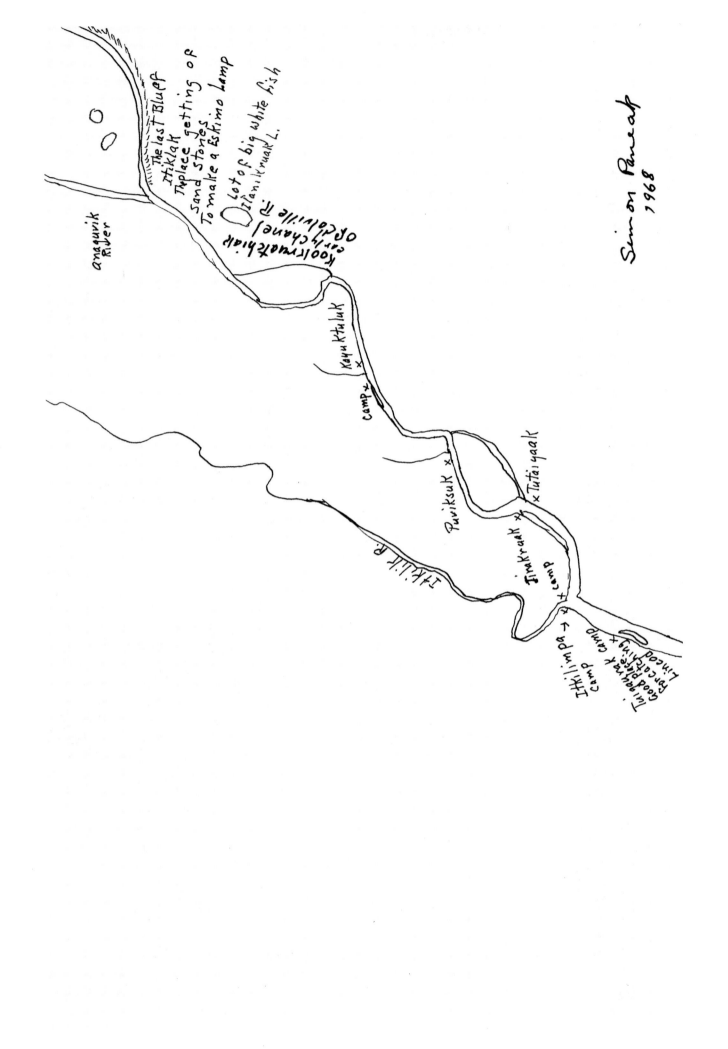

Anagurik River

The last Bluff
Itkilak
The place getting of
sand stones
To make a Eskimo lamp

Lot of big white fish
Qilanikruak L.

Koolruakhiak
early channel
of Colville R.

Kayuktuluk ×

Camp ×

Puviksuk ×

× Tutaiyaak

Jmakruak ×
× camp

Itkilimpa
Camp
camp ×
Turilphak ×
Good place
for catching
Lincod

Simon Paneak
1968

(6)

In later part of June we started to move by dog bags & packing some own also Robert Pannał had to ride on top of my pack — we have Buback no help much. We do not have magnitized hellany? but here's the sketch map Ken (in yellow) drawing

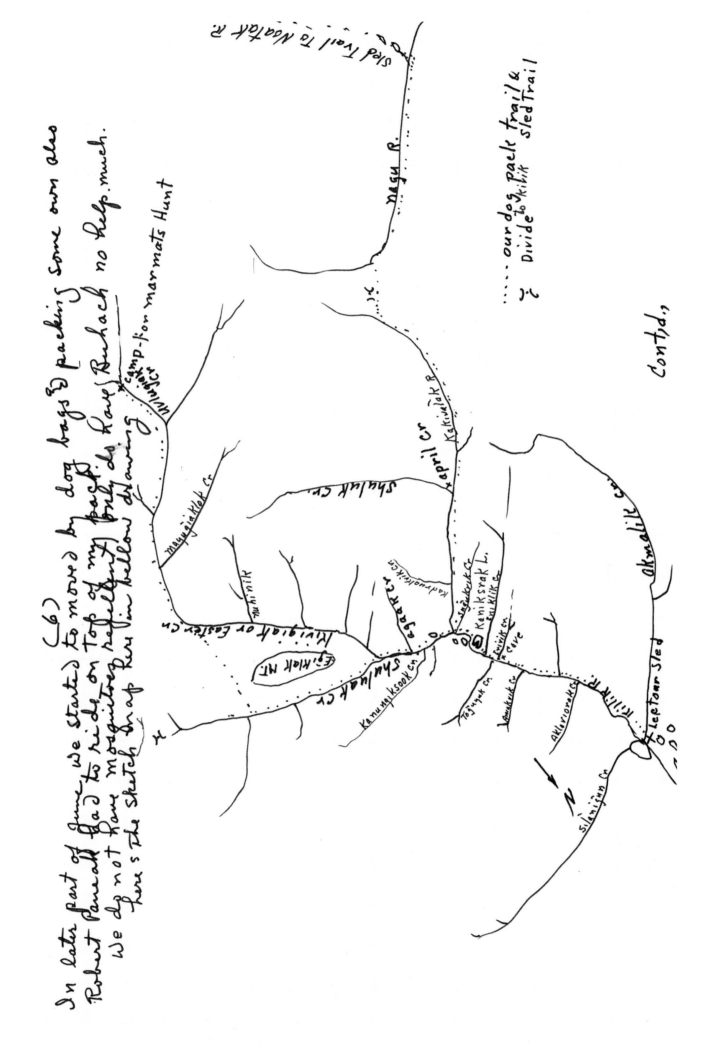

Cont'd.,

PLATE 62
WAR GAMES

When the Alaska National Guard was called to active duty in the Second World War, U.S. Army Major Marvin Marston organized Alaska Eskimos into military units known collectively as the Alaska Territorial Guard, thus ensuring that his name would come down to us as *Mukluk* Marston, *mukluk* being the popular generic Eskimo word for boot. Trained with army-issue rifles, the story of the disciplined ATG has a secure place in Alaska history (Cohen 1981, 61–66), but little if anything is known of the sort of much earlier Eskimo combat training illustrated here.

As Paneak explains, members of the two sides threw mitten-covered stones at one another, with a hit signifying a kill. As the artist notes further, as late as his early boyhood some north Alaska Eskimos practiced still with blunt-tipped arrows instead of mittened stones. Quite certainly these games related to aboriginal warfare, an uncommon but chronic part of old-time Alaska native life.

Line mark

For among Nunamiut has practiced how to be Soldier by playing with folded mitten? Ball - within but store in it (take weight or make faster?) Let hard dd & while (mittens of Ball) toward a man are quit Placut to man and lost the game of one group to start another game again. At Nunamiut as training source how to be soldier like white people Watso learning in Army's among young boys. perhaps old or middle age man taught them.

To the old people are more playing (when I was young, they still doing but I do not see plenty). by Bow & Arrow that made (a stronger?) but not up young people but said in my grandfather, & tings & more muscle? Draw better & jump better & play with Bow & arrow, Arrow Kead is horn nuthing to high Kicking. & An Eskimo Toy most is not sharp point)

he comed from Pt. 2? & (he) mime or ?(Konyuatchiak) record is around 10 feet high Kicking.
he is No.1 in high Kicking better than Nunamiut — over 10 feet the Kickeno
that was in my grandfather time, better than Nunamiut — over 10 feet the Kickeno

Simon Paneak
1968

REFERENCES CITED

Basso, Keith H. 1996. *Wisdom Sits in Places: Landscape and Language among the Western Apache*. Albuquerque: University of New Mexico Press.

Bee, James W., and E. Raymond Hall. 1956. *Mammals of Northern Alaska*. Misc. pub. no. 8. Lawrence, Kans.: University of Kansas, Museum of Natural History.

Brower, Charles D. 1942. *Fifty Years Below Zero*. New York: Dodd, Mead and Co.

Burt, William H., and Richard P. Grossenheider. 1964. *A Field Guide to the Mammals: Field Marks of All Species Found North of the Mexican Boundary*. The Peterson Field Guide Series. Cambridge, Mass.: The Riverside Press.

Campbell, John M. 1962. "Cultural Succession at Anaktuvuk Pass, Arctic Alaska." In: J. M. Campbell, ed. *Prehistoric Cultural Relations Between the Arctic and Temperate Zones of North America*. Technical Paper No. 11. Ottawa: Arctic Institute of North America, 39–54.

——. 1964. "Ancient Man in a Cold Climate: Eskimo Origins." Review of *The Archeology of Cape Denbigh* by J.-L. Giddings. *Science* 145: 913–15. Washington, D.C.: American Association for the Advancement of Science.

——. 1968. "Territoriality among Ancient Hunters: Interpretations from Ethnography and Nature." In: Betty J. Meggers, ed. *Anthropological Archaeology in the Americas.* Washington, D.C.: Anthropological Society of Washington, 1–21.

——. 1970. "The Hungry Summer." In: Philip K. Bock, ed. *Culture Shock: A Reader in Modern Cultural Anthropology.* New York: Alfred A. Knopf, 165–70.

——. 1972. *Anaktuvuk Prehistory: A Study in Environmental Adaption*. Vol. 3207B. Ann Arbor, Mich.: Dissertation Abstracts International.

——. 1976. "The Nature of Nunamiut Archeology." In E. S. Hall, Jr., ed. *The North Interior Alaska Eskimos*. Archaeological Survey of Canada. Mercury Series. Hull, Quebec: Canadian Museum of Civilization, 2–51.

———. 1978. "Aboriginal Human Overkill of Game Populations: Examples from Interior North Alaska." In: R. C. Dunnell and E. S. Hall, Jr., eds. *Archaeological Essays in Honor of Irving Rouse*. The Hague, Netherlands: Mouton Publishers, 179–208.

Clark, Annette McFadyen. 1996. *Who Lived in This House? A Study of Koyukuk River Semisubterranean Houses*. Archaeological Survey of Canada. Mercury Series paper no. 153. Hull, Quebec: Canadian Museum of Civilization.

Cohen, Stan. 1981. *The Forgotten War: A Pictorial History of World War II in Alaska and Northwestern Canada*. Vol. 4. Missoula, Mont.: Pictorial Histories Publishing Co., Inc.

Driver, Harold E., and William C. Massey. 1957. *Comparative Studies of North American Indians*. NewSeries vol. 47, part 2. Philadelphia: Transactions of the American Philosophical Society, 165–456.

Giddings, J. L. 1961. *Kobuk River People*. University of Alaska Studies of Northern Peoples no. 1. College, Alaska: University of Alaska.

———. 1964. *The Archeology of Cape Denbigh*. Providence, R.I.: Brown University Press.

Gubser, Nicholas J. 1965. *The Nunamiut Eskimos: Hunters of Caribou*. New Haven: Yale University Press.

Hulten, Eric. 1968. *Flora of Alaska and Neighboring Territories: A Manual of the Vascular Plants*. Palo Alto, Calif.: Stanford University Press.

Ingstad, Helge. 1954. *Nunamiut: Among Alaska's Inland Eskimos*. New York: W. W. Norton and Co., Inc.

Irving, Laurence. 1960. *Birds of Anaktuvuk Pass, Kobuk, and Old Crow: A Study in Arctic Adaptation*. United States National Museum Bulletin 217. Washington, D.C.: Smithsonian Institution.

Irving, William N. 1951. "Archaeology in the Brooks Range of Alaska." *American Antiquity* 17, 1: 52. Salt Lake City: Society for American Archeology.

———. 1953. "Evidence of Early Tundra Cultures in Northern Alaska." *Anthropological Papers of the University of Alaska* 1, 2: 55–85. College, Alaska: University of Alaska.

Kroeber, A. L. 1939. *Cultural and Natural Areas of Native North America*. University of California Publications in American Archeology and Ethnology vol. 38. Berkeley: University of California Press.

Kunz, Michael L. 1991. *Cultural Resource Survey and Inventory: Gates of the Arctic National Park and Preserve, Alaska*. Anchorage: U.S. Department of the Interior, National Park Service.

Longfellow, Henry Wadsworth. 1967. *Favorite Poems of Henry Wadsworth Longfellow*. With an Introduction by Henry Seidel Canby. Garden City, N.Y.: Doubleday and Co., Inc.

McKennan, Robert A. 1965. *The Chandalar Kutchin*. Technical paper no. 17. Montreal: Arctic Institute of North America.

Murdoch, John. 1892. *Ethnological Results of the Point Barrow Expedition*. Bureau of Ethnology Ninth Annual Report. Washington, D.C.: Smithsonian Institution, 3–441.

Nelson, Edward W. 1899. *The Eskimo About Bering Strait*. Bureau of Ethnology Eighteenth Annual Report. Washington, D.C.: Smithsonian Institution, 3–518.

Nelson, Richard K., Kathleen H. Mautner, and G. Richard Bane. 1982. *Tracks in the Wilderness: A Portrayal of Koyukon and Nunamiut Subsistence*. Fairbanks: University of Alaska.

Osgood, Cornelius. 1936a. *Contributions to the Ethnography of the Kutchin*. Yale University Publications in Anthropology no. 14. New Haven: Yale University.

———. 1936b. *The Distributions of Northern Athapaskan Indians*. Yale University Publications in Anthropology no. 7. New Haven: Yale University, 3–23.

Rau, Charles. 1884. *Prehistoric Fishing in Europe and North America*. Smithsonian Contributions to Knowledge 509. Washington, D.C.: Smithsonian Institution.

Rausch, Robert. 1951. "Notes on the Nunamiut Eskimo and Mammals of the Anaktuvuk Pass Region, Brooks Range, Alaska." *Arctic* 4, 3: 147–95. Ottawa: Arctic Institute of North America.

——. 1953. "On the Status of Some Arctic Mammals. *Arctic* 6, 2: 91–148. Ottawa: Arctic Institute of North America.

Ray, P. H. 1885. Report of the International Polar Expedition to Point Barrow, Alaska. Washington, D.C.: U.S. Govt. Printing Office, 7–695.

Reanier, Richard E. 1995. "The Antiquity of Paleoindian Materials in Northern Alaska." *Arctic Anthropology* 32, 1: 31–50. Madison: The University of Wisconsin.

Roberts, Kenneth. 1947. *Northwest Passage*. Garden City, N.Y.: Doubleday and Co., Inc.

Skoog, Ronald Oliver. 1968. *Ecology of the Caribou (*Rangifer tarandus granti*) in Alaska*. Parts 1 and 2. Berkeley: University of California, 69–1500; Ann Arbor, Mich.: University Microfilms International.

Spencer, Robert F. 1959. *The North Alaskan Eskimo: A Study in Ecology and Society*. Bureau of American Ethnology Bulletin 171. Washington, D.C.: Smithsonian Institution.

Stanford, Dennis J. 1976. *The Walakpa Site, Alaska: Its Place in the Birnirk and Thule Cultures*. Smithsonian Contributions to Anthropology no. 20. Washington, D.C.: Smithsonian Institution Press.

Stefansson, Vilhjalmur. 1914. *The Stefansson–Anderson Arctic Expedition of the American Museum: Preliminary Ethnological Report*. Anthropological Papers of the American Museum of Natural History. Vol. 14, part 1. New York: American Museum of Natural History.

Stoney, George M. 1900. *Naval Explorations in Alaska, with Official Maps of the Country Explored by Lt. George M. Stoney*. Annapolis, Md.: U.S. Naval Institute.

U.S. Department of Commerce. 1950–1958. *Climatological Data Alaska*. Annual Summary Vols. 36–44. San Francisco; Chattanooga; Kansas City; and Asheville, N.C. Weather Bureau.

Van Stone, James W. 1974. *Athapaskan Adaptations: Hunters and Fishermen of the Subarctic Forests*. Worlds of Man Studies in Cultural Ecology, Walter Goldschmidt, ed. Arlington Heights, Ill.: AHM Publishing Corp.

Vartanyan, S. L., V. E. Garutt, and A. V. Sher. 1993. Holocene Dwarf Mammoths from Wrangel Island in the Siberian Arctic." *Nature* 362, 6418: 337–40.

Walters, Vladimir. 1955. *Fishes of Western Arctic America and Eastern Arctic Siberia: Taxonomy and Zoogeography*. American Museum of Natural History Bulletin vol. 106, article 5. New York: American Museum of Natural History, 255–368.

Wiggins, Ira L., and John Hunter Thomas. 1962. *A Flora of the Alaskan Arctic Slope*. Arctic Institute of North America Special Publication no. 4. Toronto: University of Toronto Press.